Shoot, Edit, Share: Video Production for Mass Media, Marketing, Advertising, and Public Relations

Shoot, Edit, Share is an interactive, accessible introduction to video production techniques, concepts, and terminology. With the increasing availability of affordable video equipment, many students and professionals need to learn the basics of video production without being overwhelmed by technical details and equipment lists. Covering preproduction, production, editing in post, and distribution, this book shows you how to produce video quickly and effectively for a range of clients, from commercial firms to community service organizations.

Key features include:

- A companion website (www.routledge.com/cw/johnson) including video interviews with professionals that demonstrate and reinforce techniques covered in the book;

- Service-learning exercises that engage readers in real-world learning experiences, encouraging them to interact with their communities and new clients;

- Clear, easy to follow and heavily illustrated guides for all of the equipment and processes that go into video production;

- A focus on creating stories for a target audience, and building convincing as well as engrossing narrative through videos;

- A thorough breakdown of all the techniques needed in postproduction, including editing, well-designed graphics, and quality sound;

- A best-practices guide to viral videos, sharing video content online, and increasing its exposure on social media sites;
- QR codes throughout the book that, when scanned, demonstrate video techniques and concepts related to what was read.

Kirsten Johnson, Ph.D., is an Associate Professor in the Department of Communications at Elizabethtown College. She has a Ph.D. from Drexel University, a M.S. degree in Telecommunications from Kutztown University, and a B.A. in Journalism and Mass Communication from Drake University. Dr. Johnson worked in radio and television for nearly a decade, including WOI-TV in Des Moines, Iowa and WGAL-TV in Lancaster, Pennsylvania.

Jodi Radosh, Ph.D., is an Associate Professor of Communication and Associate Director of the Holleran Center for Community Engagement at Alvernia University in Reading, Pennsylvania. She earned a Ph.D. in Mass Media and Communications and a M.J. degree in Journalism from Temple University. She received a B.A. in Communications and English from Rutgers University. Dr. Radosh worked as a television reporter for various news stations including WGAL-TV in Lancaster, Pennsylvania.

Shoot, Edit, Share: Video Production for Mass Media, Marketing, Advertising, and Public Relations

Kirsten Johnson and Jodi Radosh

LONDON AND NEW YORK

First published 2017 by Routledge

Published 2019 by Routledge
2 Park Square, Milton Park, Abingdon, Oxon OX14 4RN
52 Vanderbilt Avenue, New York, NY 10017

Routledge is an imprint of the Taylor & Francis Group, an informa business

Library of Congress Cataloging in Publication Data

Names: Johnson, Kirsten A., 1974- author. | Radosh, Jodi, author.
Title: Shoot, edit, share : video production for mass media, marketing, advertising, and public relations / Kirsten Johnson and Jodi Radosh.
Description: New York : Routledge, 2017. | Includes bibliographical references and index.
Identifiers: LCCN 2016007813| ISBN 9781138916029 (hardback) | ISBN 9781138905429 (pbk.) | ISBN 9781315695884 (ebook)
Subjects: LCSH: Video recordings--Production and direction--Handbooks, manuals, etc. | Cinematography--Handbooks, manuals, etc. | Television in publicity--Handbooks, manuals, etc.
Classification: LCC PN1992.94 .J64 2017 | DDC 384.55/8--dc23
LC record available at http://lccn.loc.gov/2016007813

ISBN 13: 978-1-138-91602-9 (hbk)
ISBN 13: 978-1-138-90542-9 (pbk)

Typeset in Avenir, Minion and Helvetica
by Servis Filmsetting Ltd, Stockport, Cheshire

Table of Contents

Chapter 6: Shooting Video and Field Production 91

Acknowledgments

Kirsten and Jodi are both grateful for assistance from the following:

Instructional videos produced, shot, and edited by Elizabethtown College student Graham Lenker.

Interview with a Professional videos produced, shot, and edited by Alvernia University student Amber Nikolaus.

Graphics in Chapter 8 created by Elizabethtown College student Tara Siano.

Special thanks to students Amber Nikolaus and Tara Siano for their comments and suggestions about each of the chapters.

Special thanks to assistant professor of communications at Penn State University Brandywine Campus, Dr. Hans Schmidt, and local television news videographer at WFMZ-TV, Zachary DeWever, for reviewing the textbook chapters and offering helpful comments about each one.

Kirsten would like to acknowledge the following:

My wonderful husband Scott Johnson, who has always supported my work and who offers great suggestions when I'm stuck.

My fabulous and patient daughter Sarah Johnson, who agreed to pose for, and helped me with, many of the pictures in this textbook.

My Mom and Dad, Bob and Ellen Benton, who taught me the value of a college education and who constantly challenged me growing up to think creatively. Thank you for your constant support in my journey to be a professor.

And to my good-natured Elizabethtown College students who agreed to have their pictures taken for this book and never minded being used as guinea pigs for some of the material in the book.

Jodi would like to thank:

My supportive husband, Lee Radosh, who is always there for me and willing to assist with creative ideas as well as technical problems (no matter what time of night).

My adorable daughters, Rachel and Danielle Radosh, who were understanding when I was at the computer for endless hours. (Thank you for learning how to cook your own dinners during this process.) I also loved your enthusiasm during our model shoot for photos in the book.

My Mom and Dad, Susan and Frank Linder, who have been excellent role models; I am grateful for your encouragement. Thank you for your continuous love and guidance.

My sister, Lori Silver, for always being there for me.

And to my Alvernia University students, faculty, staff, and administration; I feel so fortunate to work in such an altruistic environment. I value your ongoing benevolence.

CHAPTER 1

Getting Started

Before you can begin shooting great video, you need to have a plan. That's right—a plan. The more time you spend planning, the easier your video will be to shoot and edit. This chapter begins by giving you an overview of the three phases of production: preproduction, production, and postproduction. The chapter ends with an emphasis on the importance of coming up with a good, visual idea before getting ready to shoot.

A man who does not plan long ahead will find trouble at his door.
-Confucius

By failing to prepare, you are preparing to fail.
-Benjamin Franklin

Phase 1: Preproduction

Preproduction is generally what you do before you go out and shoot your video. The more time you spend on this phase of your production, the easier the other phases of production should be.

During the preproduction phase many tasks must be completed. These tasks include coming up with a visually interesting idea, conducting research and a media audit, writing a treatment and script, figuring out where you're going to shoot, drawing storyboards, and preparing a budget. While this may sound like an overwhelming list right now, the next few pages will explain each of these elements to ensure you're on your way to a successful production.

VISUAL STORYTELLING

It's important to remember that you're producing a video, so you need to choose a subject that's *visually interesting*. If you're working for a client who has asked for a video on a topic that's inherently not visual (think—a history of economics since the 1800s), it's your job to think of ways to make it visual or convince your client that the story might be better told using a different medium.

One way to come up with visually interesting ideas is to brainstorm. When brainstorming it's important to remember that all ideas should be considered and none should be judged immediately. Feel free to come up with different and unusual ideas, because you never know when that idea you thought was really off-the-wall will lead to a creative way to approach the topic of the video.

Visually Interesting

- Pie Eating Contest
- Sports events
- Fires
- Building demolitions
- Parades
- Puppies and kittens

Visually Uninteresting

- Empty classrooms
- Budget stories
- Empty crime scenes
- Press conferences
- Empty hallways

THE TREATMENT

One of the first things you'll want to do is write your treatment. This is a document that outlines your concept for the video. Although treatments can vary depending upon who you're working for or submitting it to, they generally contain the same elements. Usually treatments are written in the third person.

Overview

Brief one- or two-sentence description of the video.

Program Objectives

What do you want this video to accomplish? Do you want to change peoples' attitudes about a given topic? Do you want to persuade them to do something? Do you want to inform them about a topic?

Target Audience

The people at whom the video is aimed or targeted are the target audience. The people in your target audience are the ones you will think about when you write the script, design the set, choose the talent (the person in front of the camera), and so on.

For example, if you're producing a recruiting video for a college, you may decide that your target audience is 17- and 18-year-old males. The video might use high-energy rock music, and the main talent might be a young male. The video may include a look at academics, fitness facilities, and campus activities. The video might also contain a series of fast-paced interviews with current students who are excited about the college.

Sample Treatment

Overview: This video will be produced for Zeager College to help recruit students.

Program Objectives: To persuade parents to allow their sons and daughters to enroll. To inform parents about the college.

Target Audience: Parents (ages of 40 to 50) of prospective college students. Caucasian. Household income of $100,000 or more.

Description: The video will begin with an interview with the president of the college focusing on the prestige of the college. Then faculty members from a variety of different departments will talk about jobs that recent graduates have attained. The video will conclude with a look at campus safety. Graphics will be used throughout to supplement the messages being conveyed on the screen. The music will be mid-tempo.

Equipment: One field camera, tripod, lavaliere microphone, and three lights.

How would your video be different if it was targeted at the parents of prospective students instead of young males? Take a look at the sample treatment to see what a treatment for this production might look like.

Description

Describe the video in this section. You should provide enough detail that the person reading it can get a clear vision of what your video is about, but it shouldn't be so long that they become bogged down in unnecessary details.

Equipment

What are your technical requirements for the video? How many cameras will you need? Will it require any special lighting? What type of microphones will you use?

MEDIA AUDIT

In addition to writing a treatment during the preproduction phase, you should also complete a media audit. A media audit is an examination of other media that's already been produced. Remember, no project is undertaken in a vacuum, and for this reason it's important to examine what is already being done. Your message is in competition with thousands and thousands of other messages, whether they are transmitted via websites, videos, podcasts, radio stations, or other platforms—so you need to understand what and who you're competing against.

Conducting a Media Audit

Overview

Begin by giving a brief overview of your project.

Examples/Analysis

Find videos that have been done that are similar to the one you're making. They should be a good representation of what is currently available. For example, if you're working on a promotional video for a website for an educational institution find web videos done for other educational institutions that are similar to the one you're working for.

For each example provide analysis.

- Why did you choose this particular website, video, or podcast?
- What is good about what you found? Be specific.
- What doesn't work? Be specific.

Don't just make a list of good or bad things for each example, instead make sure you explain (analyze) what is good or bad about what you found. Pay attention to things like shot composition, particularly interesting shots, shots you felt were misplaced, types of camera angles, and audio effects.

Usually finding 3 to 5 examples is a good place to start.

Conclusion

Explain how what you found in the media audit will inform the video you make.

- Are there any ideas or design elements you would consider including in your project based upon what you saw?
- Are there any content elements you would consider using based upon what you watched or read?

See **Appendix 1** for an example of a media audit.

If you see things you like in a video you can try to recreate (in your own way—don't exactly copy) those elements in your video. If you see things you don't like you can think about ways to fix those elements to make them work.

OTHER PREPRODUCTION ACTIVITIES

Research

Conduct research about the subject you're shooting. If, for example, you're doing a documentary about the history of the snack food industry, conduct a search for articles and talk to people who know about the subject.

Scout Locations

Think about where you'd like to shoot your video and then go and visit those locations. Sometimes locations that may seem like a great idea in your mind may end up not being so great once you go and visit them. For example, a field full of beautiful flowers may seem like a great place to shoot until you realize that the land is located next to a busy road. The noise from the road may make it hard to hear the host of your show, because the camera will pick up the sounds of cars passing by and drown out your host's voice. Also, keep in mind that the position of the sun will change depending upon what time of day you're shooting. A shot that looks great at noon may not look so good when the sun starts to set later in the day. Also keep in mind where available power sources are in case you need to plug in any of your equipment.

Hire and Schedule Crew/Talent

You'll most likely need someone in front of the camera (referred to as the "talent") and a crew (those behind the camera) to shoot the video. When developing a schedule keep in mind not only when your crew and talent are available, but also other factors, such as lighting conditions that can change based on the time of day. Shooting outside at night is extremely difficult. It's generally best to shoot during the day when you can use the sun as a light source.

Budget

The budget is an important consideration. You'll want to make sure you have more than enough money to complete your production before you begin. This will vary greatly depending upon the production. You may need to take into consideration things like how many tapes or video cards you'll need to buy, how much it will cost to rent cameras, microphones, and other equipment (if you need to), as well as paying your talent and crew.

Script

Most productions require a script that is properly formatted. The script contains important information for those involved in the production. You can find more information on proper script formatting in Chapter 5.

Storyboards

The process of storyboarding allows you to plan the story visually before you go out and shoot. This is generally done in conjunction with writing the script. For more information on storyboarding see Chapter 5.

Phase 2: Production

During the production phase you use all of the materials generated during the preproduction phase to shoot your video. Shows can be shot either in the studio, out on location, or some combination of both. Shooting out on location is also known as *shooting in the field*. So, which has more advantages—shooting in the field or in the studio? Generally shooting in studio is easier because you have more control. For example, if you're scheduled to shoot in the field and it rains, that can set you back several hours, or an entire day. In studio you don't have to worry about the weather, but one potentially major downfall is that the set can look unrealistic. It can be very difficult to create scenery (such as mountains, and superhighways) in a studio. When shooting in the field you can choose a site that specifically complements the story; however, lugging all of the equipment needed to the location can take a lot of time and be very costly. You also have to think a lot about lighting and sound. Locations outside of the studio can be very dark or very bright and may also be noisy. In the studio the cameras, microphones, lights, and recording equipment are usually readily available and can be set up quickly. In a studio, light and sound can be carefully controlled. If you're shooting a video that requires a live studio audience (like a talk show), this is often much more easily done in a studio.

WHICH IS BETTER—SHOOTING IN THE FIELD OR IN THE STUDIO?

In the Field

Pros
- More realistic setting
- More shot variety

Cons
- No control over weather
- Less control over sound and lighting

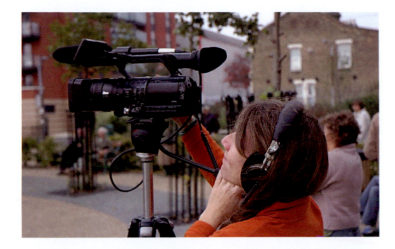

In the Studio

Pros
- Can control the environment
- No need to move equipment
- Can shoot in front of a live studio audience

Cons
- Set can look fake
- Less shot variety

Phase 3: Postproduction and Distribution

Once your video is shot you can move to the postproduction and distribution phase. During the postproduction phase, you usually are in the process of editing your video so it can be distributed to your audience. You will learn about proper editing techniques in Chapter 7. Before the video is sent to the audience, you may want to have some members of the target audience and your client review it to offer feedback for improvement.

TYPES OF EVALUATION

Formative

Formative evaluation takes place during the preproduction and production phases. In other words, while you're producing your video.

Summative

Summative evaluation takes place after the video is finished.

WAYS TO CONDUCT EVALUATION

Meetings with your client can take place during all phases of production. During these meetings make sure that you both share the same vision for the final product. It's important to stay in touch with your client throughout the entire process, otherwise you may end up producing a project that you are happy with but your client isn't.

Having people who are part of your target audience watch your video and then fill out a survey is a good evaluation technique. From these surveys you can learn what worked and what didn't. See **Appendix 2** for an example survey.

Focus groups can also be used as part of the evaluation process. To conduct a focus group, gather a small group of people who are part of your target audience, have them watch your video, and then ask them to provide feedback.

Production Process Checklist

FOLLOW THESE 7 STEPS TO ENSURE A SUCCESSFUL PRODUCTION

Step 1: Brainstorm

Do you have a good visual idea? If you do, go to Step 2. If not, you need to brainstorm. If you still can't think of a visual way to tell the story, you may need to look into a different medium for the project.

Step 2: Media Audit

Have you looked at what others have done? If so, go to Step 3. If not, you need to conduct a media audit. Examine at least three to five examples of productions others have done that relate to your video.

Step 3: Treatment

Have you defined the video's objectives and target audience? If you have, go to Step 4. If you haven't, you need to construct a treatment. What is the goal of your video? Who are you targeting?

Step 4: Script, Storyboards, Talent

Do you have a script, storyboards, and talent? If so, go to Step 5. If not, prepare these elements and find talent who you feel can convey your message. If it's an unscripted production, you should at least put together an outline of what you're hoping to hear from those you interview.

Step 5: Choose Locations to Shoot

Will you shoot in studio or out on location? If you've made this decision, move to Step 6. If not, weigh the advantages and disadvantages of each.

Step 6: Equipment Needs

Have you decided which equipment you'll need? If so, make sure you reserve the equipment in advance and then move to Step 7. If not, think about which equipment makes the most sense for your production.

Step 7: Evaluation

How will you evaluate your project? If you have already determined this, then you're ready to begin shooting! If not, think about what types of formative and summative evaluation you will use. Will you have weekly meetings with a client? Conduct a focus group or survey? Perhaps you'll choose another method of evaluation.

Activities—Put Your Learning into Action!

1. You have been asked to produce a television documentary on chocolate for the History Channel. What steps will you take during the preproduction, production, and postproduction phases, and what things will you want to make sure you consider?

2. You have been asked to produce a live college basketball game. There will be a pre-game, half-time, and postgame show. What steps will you take during the preproduction, production, and postproduction phases, and what things will you want to make sure you consider?

3. Pretend that you're making a college recruiting video. Go online and find three to five examples of these types of videos. Write a media audit based upon what you found.

4. **Service-Learning Activity:** You're working with a Spanish professor to make a video she can use when she visits local elementary schools. She generally visits first and second graders. She wants to get the kids excited about speaking a second language and also teach them a little bit about Hispanic culture. Write a treatment for this production. Now, write a second treatment, but this time the professor wants the target audience to be only girls in first and second grade. Be creative in your thinking about ways she could make an engaging video.

5. **Service-Learning Activity:** You have been asked to produce a video PSA (Public Service Announcement) for a local homeless shelter. What steps will you take during the preproduction, production, and postproduction phases, and what things will you want to make sure you consider?

 To watch an interview with a professional scan the QR code.

Appendix 1: Media Audit Example

by Julie Creveling

The Exeter School District is implementing a new Science, Technology, Engineering, and Mathematics (STEM) curriculum. The district would like to have videos made to explain to parents what these programs mean and how they are beneficial. For this media audit, three videos found on YouTube that explain STEM are analyzed.

National Academies

The National Academies is an organization that specializes in science, engineering, and medicine. The goal of the organization is to provide expert advice to the nation and increase the public's understanding in these areas. The National Academies has a YouTube channel with a video titled "STEM Integration in K-12 Education" (see Figure 1). The video was posted 11 months ago and has 34,111 views. The video is 3 minutes and 30 seconds long, and is targeted at teachers and administrators as they think about how to integrate STEM into their curriculum. The entire video is animated with hand-drawn pictures that match the script.

The close correspondence of the pictures to the narration throughout helped to reinforce the points in the script. For example, when the narrator talked about how STEM could be integrated across different subject areas in schools, a drawing of a school building was shown with STEM subject areas displayed scattered throughout the building, followed by animation showing how these different areas may be brought together.

At times, the animation did cause the narrator to take some long pauses so the drawings could be completed before moving on to the next topic, which served to slow the pacing of the video down. This could be considered a positive, because it gave the viewer time to process information before moving to the next point, but it could be considered a negative because it did serve to slow down the pace of the video. Sometimes the pictures would become animated like a cartoon, which was effective in helping to maintain visual interest in the video. Sound effects were also used to enhance the video and provide some variety.

The video's script was easy to understand and explained STEM very clearly. A pleasant, yet authoritative-sounding female voice was used. Multiple examples were given to make sure a concept was fully explained. The vocabulary used was easy to understand and refrained from using too many technical words. The video covered multiple parts of STEM. This included what STEM is, why it is important, how it is used in the classroom, and how it relates to the real world. The video ended by posing multiple questions that school districts need to consider when implementing STEM programs. It also provided viewers with a source to find more information if they are interested, in a clear and straightforward way.

The White House

The White House has a YouTube channel with a video titled "A STEM Education, Tools to Change the World" on it (see Figure 2).

This video was posted four years ago and has the most views out of any other STEM video found on YouTube, with 36,116 views. The video focuses on why STEM is important for our society. What individuals can do with a STEM education in the real world is also discussed. There is no narrator, and instead the video features interviews with three men—from a Nobel Prize winner to CEOs. Each interviewee is identified using a lower-third graphic with his name and job title, which is helpful for the viewer to identify who is talking. Music is played underneath the interviews throughout the video, which

helps make the piece more engaging and makes the pace of the video seem faster. Some b-roll footage is used but it isn't varied much. The b-roll footage consists of a few photos as well as some videos of students working in a classroom. There are also some different shots of the interviewees, such as an extreme close-up that proceeds to go out of focus, and a medium shot that starts in focus on the interviewee, blurs, and focuses on the sign behind him. The use of more b-roll could help to make the video more visually engaging, and would make it look less like a series of talking heads. The video ends with a logo from the White House, which is a good branding element.

RiAus TV

RiAus TV is Australia's national science channel, which works to promote public awareness and understanding of science. A video titled "Bringing Science to Life: What Is STEM?" appears on its YouTube channel (see Figure 3). The video was posted a year ago and has 2,218 views. The video is 2 minutes and 20 seconds long and is clearly aimed at high school students. It is fast-paced and explains different types of STEM jobs very quickly. There's a very brief introduction that explains, using graphics, what STEM stands for. This is an effective way to make sure viewers clearly understand what the acronym stands for, as it is used many times throughout the video. The video's message, that STEM provides an endless number of exciting job opportunities for people with different career goals, is clearly conveyed both visually and in the script. The entire video is animated.

This message is conveyed visually through the use of two high school students who are featured throughout the video, a boy and girl. They begin in a classroom and travel around the world exploring job opportunities. The video ends with them back in the classroom learning why they need to start concentrating on STEM now. In terms of scripting, the viewer is addressed directly by using the word "you" throughout. The video features a female voice-over, which may have been used because there is a push to get more girls to go into STEM careers. Sound effects are used throughout to keep the video exciting and engaging. The video ends by providing viewers with sources to learn more information about STEM careers.

CONCLUSION

Three different types of STEM videos were watched and analyzed. Two of these videos featured animation with voice-overs, and one featured interviews with those who have successful careers in STEM disciplines. Each video was around two or three minutes, which seemed like a good amount of time to convey the necessary information without losing viewer interest. Each of the videos had good information, but sometimes it wasn't presented in the most effective way. For example, the White House YouTube channel video lacked visual interest because not much video was used. It also didn't show good diversity in terms of gender, as it featured interviews with three men and no women. When creating the Exeter School District's videos care will be taken to feature interviews with both men and women, and to use b-roll of students in classrooms that is visually engaging. Using a mix of video footage along with animation would also keep the videos interesting.

It is important to have a clear match between what is in the script and the visual elements that are shown throughout in order to help with viewer comprehension. It is also important not to use technical language in the script, as this may serve to alienate viewers who don't understand the jargon. Clean, clear, easy to understand audio is very important. Also, a graphic at the end of the video is an effective way to help with branding, as well as to direct viewers to other sources if they want more information.

Figure 1. Screenshot of "STEM Integration in K-12 Education" video. https://www.youtube.com/watch?v=A1PJ48simtE

Figure 2. Screenshot of "A STEM Education, Tools to Change the World" video. https://www.youtube.com/watch?v=biWQZIUI-vE

Figure 3. Screenshot of "Bringing Science to Life: What is STEM?" video. https://www.youtube.com/watch?v=faMRXPhKntM

Appendix 2

VIDEO SURVEY

After watching the video please respond to the statements below.

1. I enjoyed watching this video.
 - ☐ Strongly Disagree
 - ☐ Disagree
 - ☐ Uncertain
 - ☐ Agree
 - ☐ Strongly Agree

2. After watching this video I now have a better understanding of what this organization does.
 - ☐ Strongly Disagree
 - ☐ Disagree
 - ☐ Uncertain
 - ☐ Agree
 - ☐ Strongly Agree

3. I have a more positive feeling about this organization after watching this video.
 - ☐ Strongly Disagree
 - ☐ Disagree
 - ☐ Uncertain
 - ☐ Agree
 - ☐ Strongly Agree

4. I want to volunteer for this organization after watching this video.
 - ☐ Strongly Disagree
 - ☐ Disagree
 - ☐ Uncertain
 - ☐ Agree
 - ☐ Strongly Agree

5. What were your favorite parts of the video?

6. What parts of the video do you think could be improved?

7. Are you:
 - ☐ Male
 - ☐ Female

8. What is your age?
 - ☐ 18–24 years old
 - ☐ 25–30 years old
 - ☐ 31–40 years old
 - ☐ 41–50 years old
 - ☐ 51–60 years old
 - ☐ Over 60 years old

CHAPTER 2

Studio Production

There are two different environments in which to shoot video—in a studio or out on location (field production). This chapter focuses on in-studio production and introduces some concepts that will be used later in the book to help you understand field production.

In this chapter you'll learn about the positions in a TV studio, different types of video transitions, three-point lighting, and in-studio directing.

Directing is really exciting. In the end, it's more fun to be the painter than the paint.
-George Clooney

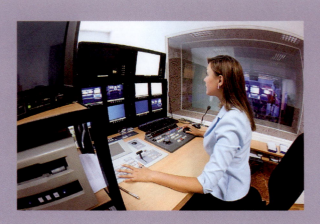

*Directing your first film
is like showing up to the
field trip in seventh grade,
getting on the bus, and
making an announcement,
"So today I'm driving the
bus." And everybody's like,
"What?" And you're like,
"I'm gonna drive the bus."
And they're like, "But you don't know how to drive the bus."*
-Mike Birbiglia

Studio Positions

As you learned in Chapter 1, the studio offers a controlled environment in which to shoot. In this chapter we'll focus on the TV studio. Usually the equipment needed is already in place. There are several positions

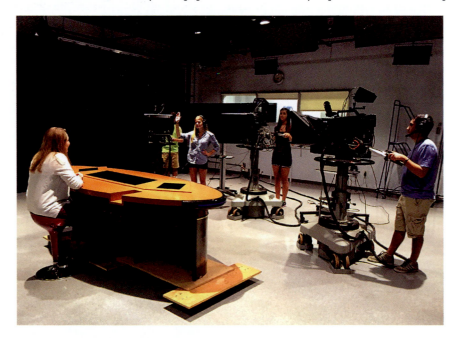

in the studio. Teamwork is essential as each person plays an important role in making sure the production goes smoothly.

Talent: This person is in front of the camera and conveys information to the audience.

Camera Operator: This person is responsible for framing shots and camera movements during the production.

Floor Director: This is the person in charge on the studio floor. The floor director gives cues to the talent, makes sure props are in place, and in some cases may also be asked to operate a camera.

Scan the QR code to see the floor director cues.

FLOOR DIRECTOR CUES

Standby: Indicates that the production is about to begin. Everyone in the studio should be quiet and prepared to start.

Cue Talent: Point at the talent so he or she knows when to start.

Stretch: Indicates to the talent that they need to make the program last longer.

Cut: Shows the talent that they need to stop whatever they are doing. If the show is being taped, this may happen because a mistake has been made and the talent needs to do something again.

30 seconds: There are 30 seconds left in the program, or a break, or a pre-taped segment in the program (like a pre-taped interview or a story contributed by a reporter).

5–4–3–2–1: This cue indicates the number of seconds left in the show. The floor director might also count down at the beginning of the show so the talent knows when to start.

Wrap: This cue is given to let the talent know that they need to wrap up what they're doing and end the segment or show.

At the end of the production the floor director may say "we're clear" to let everyone know that the production is over.

Control Room

Director: This person is in charge of the production. During the show this person calls which camera shots will be taken and is responsible for the overall look of the show. You'll learn more about the cues the director uses later in the chapter.

Assistant Director (AD): This person assists the director. Usually this person makes sure the show and different segments are running on time.

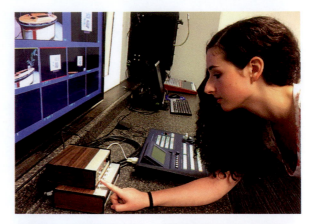

Technical Director (TD): Also called the Switcher, this person listens to the director and pushes the proper buttons on the board or the switcher to show the appropriate camera shots on the air.

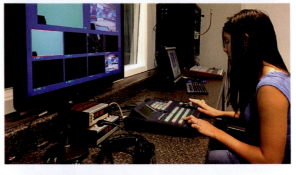

Toaster Operator: This person is in charge of making sure the appropriate graphics air during the production, and may also be called the Graphics Operator.

Audio Operator: This person is in charge of the sound during the show. This includes sound from the mics, music, taped segments, and any sound effects that are being used.

Teleprompter Operator: This person runs the teleprompter during the production. The teleprompter displays the script for the talent to read via a screen in front of the camera lens. It's important for the teleprompter operator to listen to what the talent is saying and keep the words they're reading on the screen.

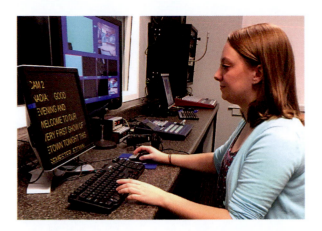

VTR Operator: This person is in charge of taping the production. When the director says *Roll tape and record*, this person hits the record button and then says *Speed* to let the director know the tape is up to speed and the recording has begun. VTR stands for Video Tape Recorder. This person may also be called the Playback Operator.

VIDEO SWITCHER

The video switcher allows shots from different sources (cameras, computers, video playback) to be shown during a program.

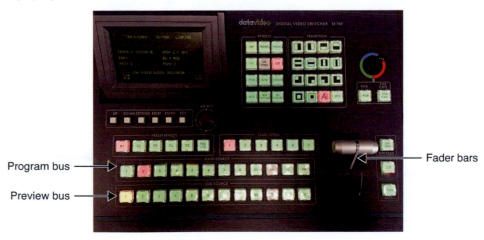

Preview bus: Pushing a button in this row allows you to preview the source before it goes out on the air.

Program bus: Pushing a button in this row selects the source and puts it on the air.

Fader bars: These allow you to control the speed of fades, dissolves, and wipes.

While different switchers have different capabilities, listed here are transitions that most switchers can perform:

Fade: This is a transition to and from black and is generally the way programs begin and end.

Dissolve: This is a gradual transition from one source to the next. It can be used to show a passage of time.

Cut: An abrupt change from one source to the next.

Wipe: One source is replaced by another, usually moving across the screen.

 To see video of each of these transitions scan the QR code.

The switcher can also be used to *chroma key*. When using chroma key the talent is recorded in front of a green or blue background, and then the green or blue in the background is replaced with another picture. This technique is commonly used to project maps behind weather forecasters. You'll learn more about chroma key in Chapter 8.

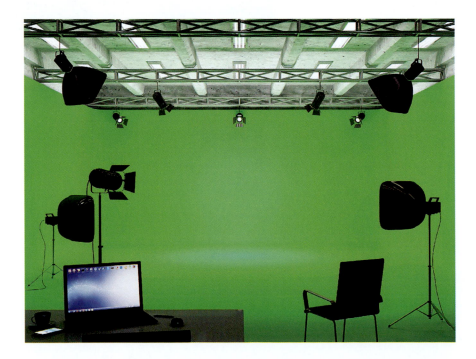

Director

The director is in charge of the production. It's important that the director understands how to deliver basic directing cues to the crew and talent. These cues are important to make sure the production begins smoothly, that elements during the show run when they are supposed to, and that the show ends without confusion and on time. It's also vital that the director remain calm even if things don't go as planned while on the air. If the director becomes frazzled so will the talent and crew.

The following is a list of basic directing cues. Depending upon where you're directing these may change.

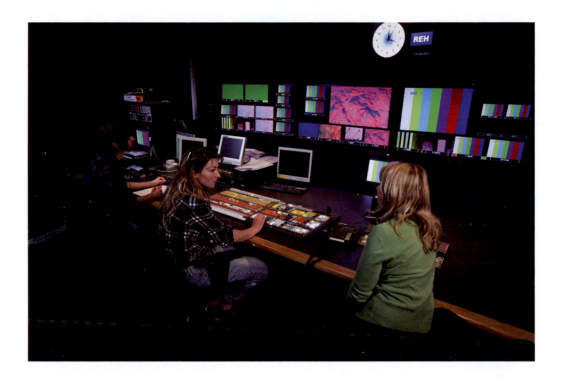

DIRECTING CUES

Usually productions begin with a cue that lets the crew and talent know the show is about to begin. When the director is ready he or she will say *Standby!* This cue alerts everyone to stop talking and pay attention to the director because the show will be underway shortly.

After the crew is ready, and if the show or segment will be recorded, the director will say: *Ready to roll tape and record*. This allows the VTR operator to know that he or she should get ready to press the record button. The director will then say: *Roll tape and record*. At this point the VTR operator pushes the record button, and when he or she knows the recording device and/or the tape is rolling, he or she will say *Speed*.

Once the director hears the VTR operator say *Speed*, he or she knows the program is being recorded and it's safe to continue the directing cues.

Next the director will look at the script and see what the next element is in the production. Let's say the first shot is on camera 1, and while we see camera 1 we also want to have music play. The director would

say, *Ready to fade up camera 1 and fade up music.* This alerts the technical director (TD) to fade up camera 1. Remember, we usually *fade up* the first shot in a production because you'll most likely begin in black, and a *fade* is a transition to or from black. The fade-up music cue indicates to the audio operator that he or she needs to be ready to play the music to begin the production. After the ready cue is given, the following cue is given: *Fade up camera 1 and fade up music.* This lets the TD know to fade up camera 1 and also lets the audio operator know to fade up the music.

Let's pretend that the next element on the script is a shot on camera 2. The script also indicates that you should fade down the music and the talent will begin reading the script. Here's what the director would say: *Ready to take camera 2, fade music down, open mic, and cue talent.* These commands let your TD know to take camera 2 on the switcher, lets the audio operator know to fade down the music and open (turn on) the talent's mic, and lets the floor director know to cue the talent.

There are also cues for ending the production. Usually productions end by fading to black. The cues a director typically uses to end a production are: *Ready to fade to black, close mic, and stop tape.* These cues alert your TD to get ready to fade to black, your audio operator to get ready to turn off the talent's mic, and the VTR operator to get ready to hit the stop button. Then the director says: *Fade to black, close mic, and stop tape.* When these cues are given, the TD fades to black, the audio operator turns off the talent's mic, and the VTR operator stops the tape.

 Scan the QR code to see video of directing cues.

Three-Point Lighting

One of the most basic and useful lighting schemes is called *three-point lighting*. Three-point lighting allows you to light a subject or prop evenly. Keep in mind that each lighting situation may present unique challenges, and in this way lighting is often as much of an art as it is a science.

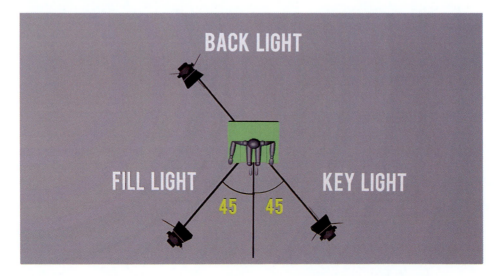

Key light: Usually the main light, used to light your main subject, which many times is your talent. The key light is usually placed to one side of the camera and pointed at your talent. It's also usually your brightest light.

Fill light: Helps to fill in areas where shadows are cast by the key light. It's usually placed on the opposite side of the camera from the key light. Usually the fill light is not quite as bright as the key light and may be more diffuse.

Back light: Usually placed behind the talent. Its main purpose is to provide some separation of the talent from the background. It helps the shot look less flat.

To see an example of how three-point lighting is done scan the QR code.

LIGHTS

A lighting plot is used to show where lights should be placed for a production. It's drawn from an overhead view and should be as detailed as possible. This is an example of a studio lighting plot.

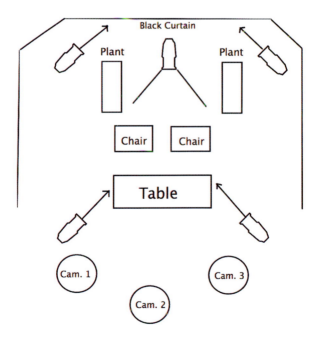

Fresnel: (pronounced fruh-NELL) One of the most common lights found in a studio. The light it produces is generally very even.

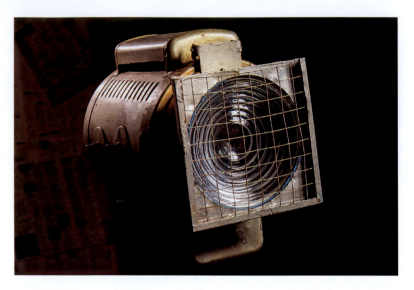

Barn doors: Light from a Fresnel can be controlled using barn doors. The flaps can be adjusted to either focus the beam of light or make it more diffuse.

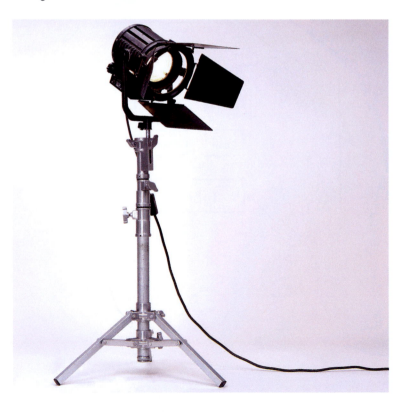

Scoop lights: These are generally used for flooding an area with a lot of light. The light from a scoop isn't as focused as the light that comes from a Fresnel.

Light meter: A handy tool to use when setting up your lighting, this tool measures the amount of light that's being cast on your set (*incident light*). It can also measure the amount of light being reflected off of your set (*reflected light*).

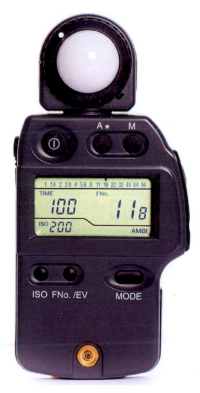

Floor Plan

Floor plans, like lighting plots, make it easier for everyone to visualize the production. Floor plans are used if you are going to shoot your video in a studio. A floor plan is an overhead diagram of what you plan to shoot. For an accurate floor plan it's best to get the dimensions of the studio. You can use a piece of graph paper and determine the scale you want to use (for example, 1 box = 1 ft. × 1 ft.). You can begin by drawing all of the studio walls and areas where you will shoot. Then you can draw the set pieces, scenery, and stage props. You can refer back to your storyboard to identify the actors and camera angles in each shot. This will help you determine the lights and camera placement for your floor plan. It is important to allow room for the cameras to obtain all the camera angles that are needed during the production. A floor plan can also be useful for microphone placement. The floor plan can be thought of as a production blueprint. It helps the entire video production crew anticipate the shoot, and in some cases it can identify problems before they happen.

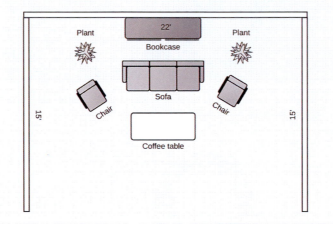

Directing Checklist

FOLLOW THESE 6 STEPS TO MAKE SURE YOU'RE READY TO DIRECT YOUR PRODUCTION

Step 1: Script

Do you have a script? If you do, you're ready to move to Step 2. If you don't, you need to get one before you begin directing.

Step 2: Studio Ready

Have you made sure you have all the things in the studio that are needed for your production? Do you have a floor plan? Have you chosen a set? Do you have the props you need? Are your lights in place? If so, move to Step 3. If not, you need to make sure you have a clear idea of what your set looks like and where the lights will be located. Also, any props needed have to be obtained and properly placed.

Step 3: Know Your Script

Have you become familiar with your script? If so, you can move to the next step. If you haven't then you need to make sure to read through the script and have a clear vision of what the viewer should see and hear. It can be helpful to make notations on your script to make directing easier.

Step 4: Communicate with Your Crew

Have you communicated any special camera moves, lighting effects, or audio needs with your crew? If so, move to the next step. If not, remember that good communication and teamwork are the keys to a good, smooth production. Communicate directly with camera operators if there are any tricky or unusual shots. If there are any special audio elements, make sure you talk to your audio operator. For example, if you

need a certain sound effect at a certain time, make sure you tell him or her. If there are special lighting needs, make sure you talk to your floor director or the person responsible for the lighting.

Step 5: Communicate with Your Talent

Have you communicated with your talent? If not, make sure your talent is comfortable with the script and any special camera moves that may occur during the production. Making your talent feel comfortable and confident is important. Remember, your talent is the face of your production. If they're feeling uneasy your entire production won't go well. If you've communicated with your talent move to Step 6. If you haven't—go talk to him or her.

Step 6: Rehearse Your Directing Cues

Have you rehearsed your directing cues? Rehearsing directing cues and visualizing the production in your mind will make you less nervous during your production. It will also help you feel more in control and allow you to engage in *heads-up directing*. This means that instead of staring at your script, you'll be able to look at the monitors during the production and adjust shots during the show. If you've rehearsed your cues then

you're ready to begin directing. If you haven't, you need to do so. Practicing in front of a mirror can be a good idea and will make you aware of how often you're looking at your script.

Activities—Put Your Learning into Action!

1. You are directing a production. Pretend that you have one talent (with a mic) and music to use at the beginning of your production. You will start with a shot of the talent on camera 1 with music under. She will introduce the show, and then talk as the music fades down. She will then read the script on camera 3. What are the cues you use to begin this production? In other words, from the time you're ready to begin until the talent ends up on camera 3.

2. You have been asked to draw a lighting plot for an interview that will be done in studio. One camera will be used, and there's one talent. Using your knowledge of three-point lighting, where will you place the key, fill, and back lights?

3. Using a lighting kit, practice setting up three-point lighting in different locations. Take note of how placing the lights farther away from or closer to the subject changes how the subject is viewed.

4. **Service-Learning Activity:** You've been asked to shoot an in-studio 30-minute interview show for the American Red Cross. They'd like to highlight the experiences of two of their volunteers who traveled to New Orleans to help those in need following Hurricane Katrina. You will have a host and two guests. Draw a floor plan and a lighting plot for this production.

 To watch an interview with a professional scan the QR code.

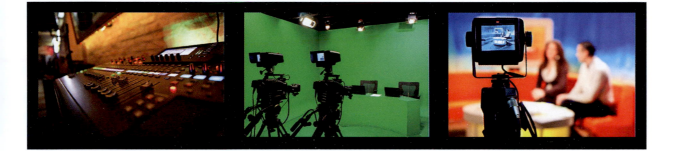

CHAPTER 3

The Camera

Whether the camera you're using cost tens of dollars or thousands of dollars, there are some essential skills you need to make your video look great. In this chapter you will learn about different types of shots and camera movements, as well as what it means to white balance and critical focus the camera. All of the skills learned in this chapter will help you with any type of production you do, whether it's in the studio or in the field.

Do the one thing you think you cannot do. Fail at it. Try again. Do better the second time. The only people who never tumble are those who never mount the high wire. This is your moment. Own it.
-Oprah Winfrey

If I could tell the story in words, I wouldn't need to lug a camera around.
-Lewis Hine

Parts of the Camera

Studio Camera

Viewfinder

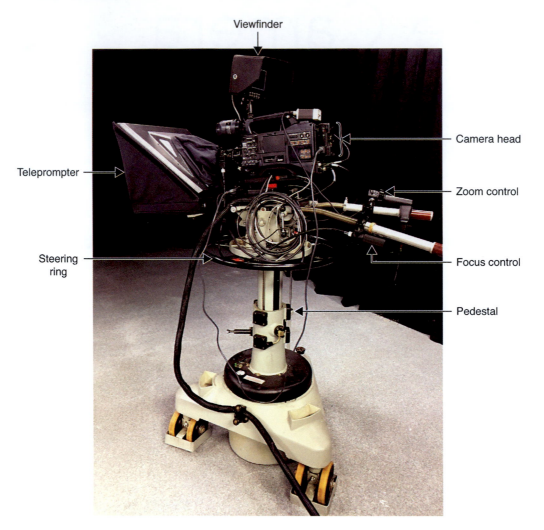

Teleprompter

Steering ring

Camera head

Zoom control

Focus control

Pedestal

Field Camera

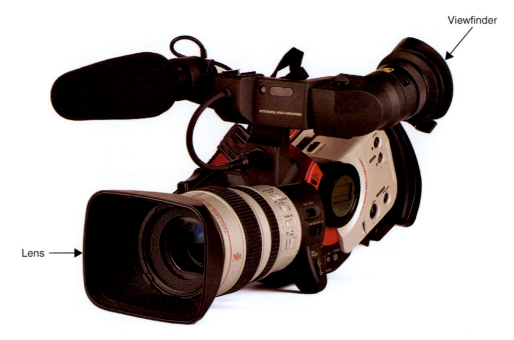

Viewfinder

Lens

Viewfinder: Allows you to see the picture that the camera is producing. It helps you frame your shot and determine whether it's in focus.

Camera head: The part of the camera that contains the viewfinder and the lens.

Lens: Collects light coming into the camera and focuses it on the device in the camera that produces the image.

Teleprompter: A device that allows the script to be projected in front of the camera lens so the talent can see it and maintain eye contact with the audience.

Zoom control: Allows you to zoom the camera picture in and out. The camera doesn't move when zooming.

Focus control: Allows you to focus the camera.

Steering ring: Allows you to move the entire camera around.

Pedestal: The base the camera sits on. It usually has wheels to allow you to move the camera around easily and make smooth on-air camera movements.

Types of Shots

There are several types of shots you can use to add visual interest to your production. Many of the shots you'll learn about in this chapter are the basic building blocks you'll need to use to shoot and edit great video. You should use a tripod whenever possible to shoot your video to make it look professional. You'll learn more about using a tripod in Chapter 6.

SEQUENCE OF SHOTS

A sequence of shots is a series of shots that are related to each other, and when edited together they help to tell your story in a logical and visually engaging way. These shots generally either start by showing your subject from far away and then moving closer to that subject, or start close to your subject and then move the viewer farther away. A basic sequence is usually made up of the five shots that follow; however, simpler sequences may have fewer, and more complex sequences may have more.

Here are examples of the different types of shots that are used to build sequences. If you master these different types of shots and how they work together, you'll be well on your way to putting together a professional-looking video.

Extreme Long Shot (XLS or ELS): A shot that is taken very far away from the subject. Very little specific detail can be seen in the shot. Sometimes drones, aircrafts that are controlled remotely and have a camera attached to them, or manned helicopters are used to capture these shots. Many times these are exterior shots. These shots can also be called *Establishing Shots* because they can help establish in viewers' minds where a scene is taking place. This shot can also be called an *Extreme Wide Shot*.

Long Shot (LS): This shot is still quite far away from the subject, but is closer than the Extreme Long Shot. Long Shots can be exterior shots designed to bring your viewer a bit closer to the subject, but they don't have to be exterior shots. A little more subject detail can be seen in this shot. This shot can also be called a *Wide Shot*.

Medium Shot (MS): This shot brings you closer to the subject than the Long Shot and more detail can be seen. Many times you can see the subject from the waist up.

Close-Up (CU): This shot brings you even closer to the subject than the Medium Shot. This shot is used to show the details of your subject, often the face.

Extreme Close-Up (XCU or ECU): An Extreme Close-Up moves you even closer to the subject than the Close-Up. It is used to show intimate details of your subject. These shots can be used to convey emotion to the audience.

If you shoot an XLS, LS, MS, CU, and XCU, you've shot a basic sequence. These shots can be used together to help you tell your story. Using a sequence of shots to tell your story is a good idea, because it helps your audience understand what's happening in a logical way. If you begin with an XLS and move your viewer, shot by shot, closer to the action, they will be able to understand the context in which the action is happening. Think about it this way: if you're shooting an event on campus and the first shot you show your viewer is an MS of someone sitting in the audience at the event, they have no context for what they're seeing. If you start with an XLS or LS of the building or room in which the event is being held and then move to the MS of someone sitting in the audience, your viewer now has the context they need to better understand your story.

Sequencing your shots can also help you compress a long action (like someone dribbling a ball down a soccer field) into a three-, four-, or five-shot sequence that only lasts 20 seconds, instead of the long amount of time it would take to show the entire action.

It should be noted that a sequence doesn't have to begin with an XLS. It can also be shot and edited together by starting with an XCU and ending with an XLS.

To see video of a basic sequence of shots scan the QR code.

It should be noted that many beginning videographers make the mistake of getting too many long and medium shots, and not enough close-ups. Close-ups make your video interesting, because they move you close to the subject and can be used to show details in a scene. Don't be afraid to move your camera as close to the subject you're shooting as you can physically get. Many times the temptation is to get CUs using the zoom control, but you'll often get better results by moving the entire camera close to your subject. It can be intimidating at first to move very close to someone and get a nice CU shot—but be bold and don't be afraid to show the intimate details of a scene to your viewer.

OTHER TYPES OF SHOTS

These are the other types of shots you can get to add even more visual variety to your videos.

Bust Shot: Shows a person from the middle of the chest up.

Knee Shot: Shows a person from the knees up.

Two-Shot: Shows two people in the shot. It's good for showing a relationship between the people in the shot.

Three-Shot: Shows three people in the shot. It's also good for establishing a relationship between the people in the shot.

Over-the-Shoulder (OTS): The camera is positioned behind a person who's looking at the subject. The viewer can see part of the shoulder and head of the person looking at the subject. This type of shot is often used to show a conversation.

To see video of these other types of shots scan the QR code.

Breaking Action Down

When shooting video it can be helpful to think about breaking actions down into their smallest parts. For example, let's say you're shooting a scene where someone gets into a car and drives away. You've decided you don't want to show this as one continuous shot, so you need to break this action down into smaller pieces so you can edit them together later. Here's one way you could do this.

You could start by getting an LS of the person walking up to the car.

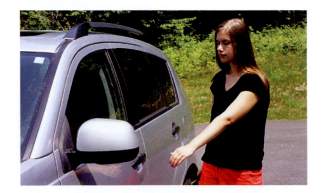

Next, get a CU of the person's hand coming into the shot, grabbing the door handle, and pulling it open.

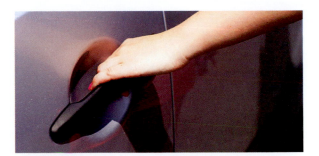

After that, get an MS of the person getting into the car.

Next, get a CU of the key being put into the ignition and the key turning.

Then you could get shots of the person looking into the mirrors and adjusting them.

You could get a CU of the person's hands on the steering wheel.

Finally, get a long shot of the car driving away.

Do you see how one continuous shot can be broken down into many smaller shots? Breaking action down into smaller pieces will add visual interest to the stories you're telling.

Camera Movements

There are several types of camera movements you can use to add additional visual interest to your video. However, camera moves, especially for beginning videographers, should be used with caution. The temptation to move the camera constantly will be great, but you need to resist this urge. Practicing these camera moves prior to shooting your video is a must.

Pan: Moving the head of the camera left and right. This is often used to track a subject's movement, like a person running or driving.

Tilt: Moving the head of the camera up and down. This shot is often used to show how tall something is, like the height of a building. You could start at the bottom of a building and tilt up to show how tall the building is.

Zoom: This allows you to move your viewer either closer (if you're zooming in) or farther away (if you're zooming out) from your subject without moving the camera. Because zooming is so easy to do, it is often overused. Remember, the human eye cannot zoom, so it can seem unnatural to see a shot that is zooming in or out. It's often better to move the camera physically closer or further away from your subject as opposed to zooming.

Dolly: Moving the entire camera forward and backward (closer or further away from your subject). In order to dolly you must have either wheels on your pedestal or tripod or tracks for the tripod to glide along. Without a smooth surface to put the camera on, these shots can't be done well.

Truck: Moving the entire camera left and right (from one side of the set to the other). These shots require that you have a smooth surface and either wheels on your pedestal or tripod or tracks for the tripod to move along. A smooth surface is required for these types of shots.

Pedestal: Moving the entire camera up and down. It is also a term that refers to the base that a camera sits on. Generally these bases have wheels so that the dollying and trucking movements are smooth.

 Scan the QR code to see video of each of these camera movements.

Many times, instead of moving the camera it is best to simply let the action that's taking place move in and out of your shot. Let's say you're getting video of cars driving down the street. Instead of panning your camera and following each car, allow the cars to simply move in and out of your shot.

 For examples of shots that allow action to move in and out of the frame scan the QR code.

Camera Features

There are some important features on your camera that you can use to make sure the video you're shooting is the right color and in focus.

WHITE BALANCING

White balancing is important to do so the color of your video is correct. Basically, when you white balance, you're telling the camera what color white is under a particular lighting condition. You may wonder why you need to do this. Here's why—different lights have different color temperatures. You may have noticed this if you're in different rooms with different types of light (incandescent versus fluorescent) or the difference between sunlight and light from a light bulb.

White balancing needs to be done every time your lighting conditions change. If you're shooting outside and then decide to get some shots inside, or vice versa, you need to white balance. Or, maybe you're shooting in a sunny classroom, and then you interview a professor in a dimly lit office. In this case, you'll need to white balance when you get to the office. If you don't your video could have a blue or yellowish hue to it.

To white balance, place something white (usually a white piece of paper or a card) at the spot where you will shoot your video. Zoom all the way in on the white object, and then find the white balance button or switch on your camera and push or slide it.

NEUTRAL DENSITY FILTER

This is a switch on the camera that limits the amount of light that comes into the camera. This is useful if you're shooting in very bright conditions, such as a sunny day with no clouds.

IRIS

The iris is used to control how much light comes into the camera. The wider the iris is open, the more light is allowed into the camera, and the brighter your picture will be.

CRITICAL FOCUSING

Critical focusing is, well, a critical part of shooting video that's in focus. This is particularly important when zooming the camera in. Failure to critical focus will usually result in a zoom that begins in focus, but as you move closer to your subject, the shot ends up out of focus. To critical focus perform the following steps:

- Switch your camera into manual focus.
- Zoom in as tight as you can on your subject (the eyes are a good place to do this).
- Adjust your focus until the picture is sharp.
- Zoom back out and frame your shot.

Now when you zoom in your shot will be in focus. If you decide to move your camera you will need to go through the process of critical focusing again.

 To see how critical focusing is done scan this QR code.

Shooting Great Video Checklist

FOLLOW THESE 4 STEPS TO MAKE SURE THE VIDEO YOU SHOOT LOOKS GREAT

Step 1: Know Your Camera

Have you spent time getting to know how your camera operates? If so, go to Step 2. If not, take some time to understand what the different parts of the camera are and what they do, before you go out on your shoot.

Step 2: White balance

Did you white balance your camera? If so, go to Step 3. If not, make sure you white balance your camera otherwise your video could end up with a blue or yellow tint to it. Remember to white balance each time your lighting conditions change.

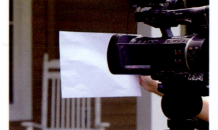

Step 3: Sequence Your Shots

Did you get a variety of different shots? If so, go to Step 4. If not, make sure you get a number of different shots, using your tripod whenever possible—everything from long shots to extreme close-ups. Remember, close-ups are vital to bringing your viewer close to the action, so make sure you get plenty of these. Resist the temptation to get only medium and long shots.

Step 4: Break Action Down

Did you break each big action down into its smallest, individual parts? If so, you're ready to shoot great-looking video. If you didn't then you need to take each action you're shooting (like someone getting ready for work in the morning) and think about the different actions that make up this large action (turning on the bathroom light, looking into the mirror, picking up a toothbrush, putting toothpaste on the toothbrush, etc.). You'll have much greater shot variety if you shoot actions this way.

Activities—Put Your Learning into Action!

1. Use a video camera to get a sequence of shots of someone or something (XLS, LS, MS, CU, XCU).
2. You've been asked to shoot a story about a new food truck the college has purchased. What are some possible sequences of shots you could get for this story?
3. For a story you're working on you need to show someone unlocking his or her bike and then riding away. Using what you learned about breaking down action into its smallest parts, come up with possible shots you could use to tell this story.

4. Using a video camera practice the following camera moves. Work on making sure all of your movements are smooth.

- Pan
- Tilt
- Zoom
- Dolly
- Truck

5. Shoot video using the different neutral density filter settings to see how it changes what your video looks like. Now turn off the neutral density filter and change the iris settings to see how this impacts your video.

6. **Service-Learning Activity:** A local animal shelter would like you to shoot a story about cats and dogs that are up for adoption. What are some possible sequences of shots you could shoot for this story? The shelter lets volunteers take the dogs out for walks. They also let volunteers pet and play with the cats in a special room for visitors. Using what you learned about breaking down action into its smallest parts, come up with possible shots you could use to tell these stories.

 To watch an interview with a professional scan the QR code.

CHAPTER 4

Sound

Recording great sound is just as important as shooting great video. People usually won't notice if your audio sounds good, but they will notice if your audio sounds bad. In this chapter you will learn how to choose the right microphone for your production, as well as make sure your audio quality is as good as possible.

Beethoven said that it's better to hit the wrong note confidently, than hit the right note unconfidently. Never be afraid to be wrong or to embarrass yourself; we are all students in this life, and there is always something more to learn.
-Mike Norton

If all difficulties were known at the outset of a long journey, most of us would never start out at all.
-Dan Rather

Types of Microphones

When you are in the planning stages of your production, it's just as important to think about the audio as it is to think about the video. The selection of the proper type of microphone is crucial. The following are some of the different types of microphones you can choose and their best uses.

Handheld microphones are held by the talent. These microphones are often used by reporters interviewing someone in the field. They allow the talent to have control over the audio being recorded, because he or she controls how far the microphone is away from the source of the sound.

Lavaliere microphones are microphones that are attached to the talent, usually in the neck area. These microphones are small and often worn by news anchors, but they can be worn by others as well. Lavaliere mics are useful any time you want your talent to have their hands free. You have to be careful when using a lavaliere mic, because any piece of clothing or hair that hits the microphone will make unwanted sounds. When placing a lavaliere mic on your talent make sure the cord is not visible. This is usually achieved by running the cord up and under the talent's shirt, or hiding the mic cord behind a tie or blazer.

Headset mics are worn on the head and have earphones so the talent can hear the program. Headset mics are typically worn by talent who are in loud environments, such as a sportscaster at a game. The microphone is positioned right under the talent's mouth so he or she can be easily heard.

Shotgun microphones are used to record sound from a specific area. They are held off camera and aimed at the area where the sound is to be recorded. Shotgun mics are very sensitive to sound and should be handled carefully so you don't record the noise of the microphone being handled.

A boom microphone is the name given to any type of mic that's attached to a boom. A boom is a pole that holds the mic. It is used to record sound in a scene, without being seen. The person operating the boom mic positions the mic as close to the sound source as possible, while keeping the mic out of the shot.

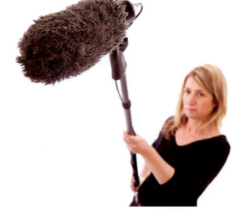

Many cameras have microphones built right into them. These mics can be good for gathering natural sound. Natural sound (also called *nat sound* or *ambient sound*) are the sounds you hear all around you. For example, if you go to the scene of a fire, some examples of natural sound are—sirens, people yelling, the sound of a firetruck as it drives away, the sound of the water coming out of the hose as it hits the structure. While these mics are good for gathering natural sound, they aren't good at gathering interview sound because they tend to pick up too much background noise. Also, you can rarely get the microphone on a camera close enough to your interviewee's mouth to pick up clear sound. So don't rely on the camera's built-in microphone to record audio during interviews, instead use either a handheld or lavaliere mic.

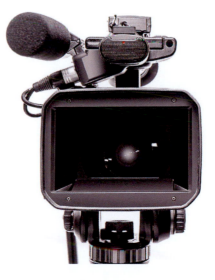

WIRELESS MICROPHONES

Wireless microphones send the signal to a receiver, instead of through a cable. This allows the talent to move around more freely, instead of being stuck in one place by a cable attached to a wall or a camera. If you're using a wireless microphone make sure you have plenty of batteries.

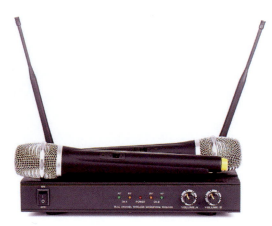

A NOTE ABOUT WIND

Wind can be the enemy of collecting good audio. If a gust of wind hits your microphone it makes a terrible sound. If you're recording on even a mildly windy day, you'll want to make sure you have a *windscreen* (a foam device that slips over the mic) with you to keep the wind from ruining your audio.

The windscreen is the foam piece you see on this lavaliere microphone.

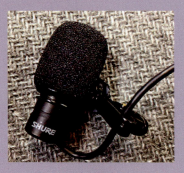

This is what a windscreen for a handheld microphone looks like.

Here's an example of a windscreen for a boom mic.

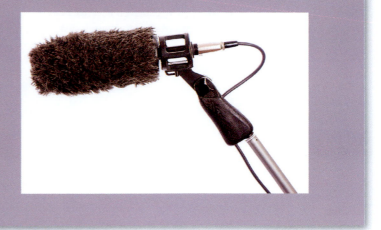

Pickup Patterns

A microphone's pickup pattern refers to the direction in which the microphone picks up sound. It's important to understand a microphone's pickup pattern so you can choose the appropriate microphone for your production. Here are the different types of microphone pickup patterns.

A cardioid pickup pattern is a type of unidirectional pattern. A microphone with this pickup pattern picks up sound in a heart-shaped pattern. It picks up sound well in the direction the mic is pointed, but not as well from the sides and rear. This is a good pickup pattern to use when you only want to pick up sound from one person or area at a time.

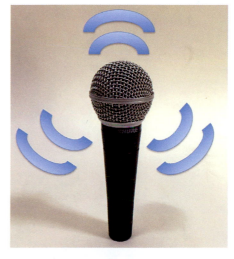

The supercardioid pickup pattern is also a type of unidirectional pattern. These types of mics pick up sound best in the direction the microphone is pointed, and they pick up very little sound from the sides and rear. Supercardioid mics pick up sound even better in the direction the mic is pointed than the cardioid mic. These types of mics are useful if you're trying to pick up sounds in a particular direction that are far away.

An omnidirectional microphone picks up sound equally well from all sides. This pickup pattern is effective in areas where you want to record all of the sounds in a scene at equal levels.

Audio Board

When audio signals from different sources need to be controlled for a production and mixed together, an audio board is usually used. For example, if you're doing a program where you need to mix together the talent's voice and music, an audio board can be used.

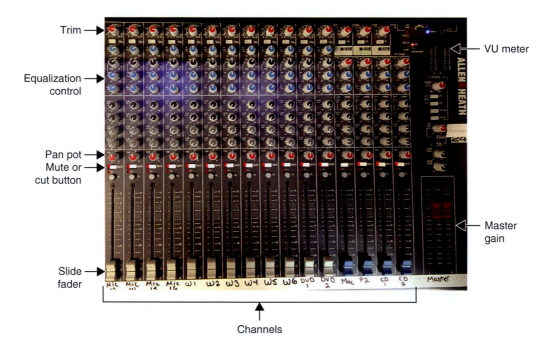

Channel: Boards are arranged into different channels. The more channels the board has, the bigger it is. Each channel represents a source (microphones, music, etc.) coming into the audio board. Each channel has several knobs associated with it that allow you to control the sound.

Trim: The trim control allows you to boost a weak signal from the source coming into the audio board. For example, if you have a microphone connected to your audio board but the signal is very weak, you can raise it by turning up the trim control.

Pan pot: This knob allows you to control whether the sound will be heard out of the left, right, or both speakers. Turning the knob to the right will make the sound more present in the right speaker, and turning it to the left will make it more present on the left. If the knob is in the middle, the sound will be heard equally out of both speakers. If you've ever been sitting in a movie theater and heard sound coming from speakers on one side of the theater and then a different sound coming from the speakers on the other side, the sound has been panned from one side to the other. Panning the sound gives your audience the feeling that they're surrounded by the action.

Equalization control: These knobs give you control over the quality of the sound. For example, if you want a voice to sound lower, you turn up the knob that controls the lower frequencies.

Slide faders: These allow you to either turn up or down the sound on each individual channel. They also allow you to fade up and fade down audio during a production. When audio is faded up (for example at the beginning of a program) it is gradually brought up by the audio operator by slowly sliding the fader up. To fade down audio, begin with the audio turned up and slowly slide the fader down to the bottom.

Mute or cut button: This button allows you to open and close the audio for each channel. Opening (or turning on) the channel means that you can hear the audio. If a channel is closed (or turned off), you will not be able to hear the audio.

Master gain: This allows you to either turn up or down the audio on all of the channels at one time. If you're ever using the audio board and you don't hear audio coming through any of your channels, make sure that the master gain is turned up.

VU (volume unit) meter: A visual way to tell how loud or soft your audio is. Most VU meters have a scale that ranges from negative –20 dB to +9 dB (decibels).

MONITORING SOUND

When recording a production it's important to monitor your sound at all times. The VU meter plays an extremely important role in doing this.

Digital VU meter.

Analog VU meter.

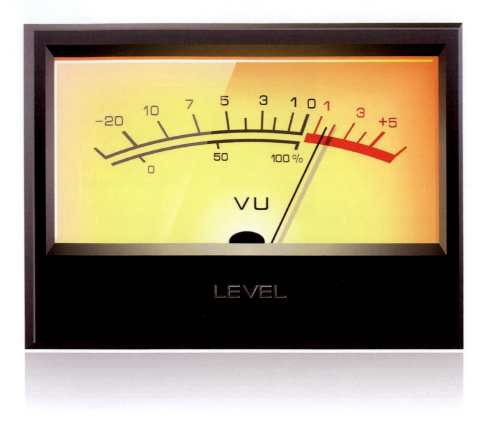

When looking at a VU meter, you'll see that most run from –20 dB to +9 dB. Sounds in your production should peak right around 0 dB. Sounds that are allowed to go above 0 dB may sound distorted. Sounds that are on the lower end of the scale (around –15 to –20 dB) may be too soft to be heard. It is okay for your audio levels to occasionally go above 0 dB and peak "in the red," but that should only be allowed for the very loudest sounds.

To learn more about VU meters and how to read them scan the QR code.

You don't want to do what's called "riding the gain." When you ride the gain you are constantly adjusting your audio levels and not ever letting your loudest sounds peak in the red, or allowing the quieter sounds to remain on the lower end of the dB scale. Every program is going to have some sounds that are louder

than others, and you should allow those variations in sound to be heard. The key is to make sure the sounds are not staying at one end of the scale or the other.

Wearing Headphones

When monitoring audio quality it's important to wear headphones. This is especially important if you're recording audio in the field and aren't sure whether the camera is picking up any audio.

Conducting A Mic Check

Before you begin recording sound you should conduct a mic check.

- If the person is reading from a script, ask them to start reading the way they are planning to read during the production.
- If the person doesn't have a script, you can ask them to start talking. Often people who haven't been in front of a camera before won't know what to say, so you can either try to carry on a conversation with them, or ask them to say their ABCs or count to 10.
- While they're talking look at your VU meter and make sure you hear them through the headphones.

You should never tap a microphone when testing it, because there are small pieces inside that can be easily damaged.

AUDIO CONNECTORS

There are several different types of audio connectors you can use. Here's a quick look at some that are used most often.

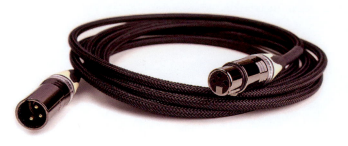

XLR connectors are used mainly in professional level equipment. These connectors have three prongs.

Phone connectors are used on both professional and consumer level equipment for microphones or headphones.

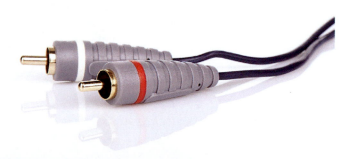

Mini plugs are usually used in consumer level equipment for microphones and headphones.

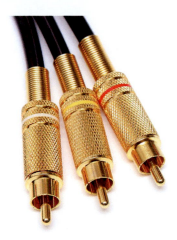

RCA Phono plugs are mainly used in consumer level equipment for microphones and headphones.

Audio Production Checklist

FOLLOW THESE 4 STEPS TO MAKE SURE YOU RECORD GREAT AUDIO FOR YOUR PRODUCTION

Step 1: Know Your Recording Location and What You're Recording

Have you chosen a location to record your audio, and do you know what type of audio you'll be recording? If so, move to Step 2. If not, think about where you'll be recording your sound, what you'll be recording, and how the recording location will impact the quality of the audio you'll be able to record.

Step 2: Choose Your Microphone

Have you chosen your microphone? If so, move to Step 3. If not, after considering where you'll be recording, and what type of sound you'll record, select a mic that will allow you to record the cleanest possible sound.

Step 3: Microphone Placement

Have you placed your microphone in the best location? If so, move to Step 4. If not, try to place your microphone as close to the source of the sound as possible. For example, if you're using a lavaliere microphone to record an interview, you'll want to make sure the microphone is close to the person's mouth, without causing distortion. In general, a microphone placed too far away from the source will produce a hollow and distant sound.

Step 4: Monitor Your Sound

Are you wearing your headphones and looking at a VU meter? If so, you're ready to record your sound. If not, you'll want to make sure you get a mic check from your talent and check to see if the VU meter is peaking at the right level. You'll also want to make sure you're wearing headphones so you can hear the audio while it's being recorded.

Activities—Put Your Learning into Action!

1. You're going to do a story on the championship lacrosse game this weekend. You plan to record sound from the game itself, and also to do interviews with fans, players, and coaches. What types of things will you need to keep in mind when choosing the appropriate type of mic(s) to use? Which type of mic do you think would be best for recording sound in each of these situations?

2. You've been asked to shoot a promotional video for a new program that's being launched in the community. You're going to shoot an interview with the president of the company that's sponsoring the new program. If the weather cooperates, you'll shoot the interview outside. What types of things will you need to keep in mind when choosing the appropriate type of mic? Which type of mic do you think would be best for recording sound in this situation?

3. You're going to shoot a commercial for the campus bookstore. The script calls for the bookstore manager to talk about the advantages of buying books in the store, as opposed to buying them online. You also need natural sound of students pulling books off of shelves, putting them into baskets, and paying for them. What types of things will you need to keep in mind when choosing the mics? Which types of mics do you think would be best for recording?

4. You're preparing to do a live remote production from a basketball game. You'll have two commentators sitting at a table, and four cameras in the gym. What types of things will you need to keep in mind when choosing the appropriate type of mic? Which type of mic(s) do you think would be best for recording sound for this production?

5. Interview a classmate using the built-in microphone on the camera, a lavaliere mic, and a handheld microphone. What are the advantages and disadvantages of using each? How does the sound quality from each mic compare to the others?

6. Go to a busy area (like the student center on campus) and record an interview. Place the microphone far away from the subject's mouth and then move it closer. What difference does the mic placement make when recording the sound?

7. **Service-Learning Activity:** You've been asked to shoot a video for a campus organization that is collecting hats for children with cancer at a local hospital. The hats are being collected at your university's basketball game. During half-time at the basketball game there will be a special show with a presentation of all of the hats. There will also be half- and full-court shot contests for charity. You need to get natural sound as well as interviews with student organizers, spectators who donated hats, and basketball players participating in the contests for charity. What types of things will you need to keep in mind when choosing the mics? Which types of mics would be best for interviews? Which types of mics would be best for getting natural sound of the hat presentation during the half-time show? Which types of mics would be best for getting sound of spectators clapping during the half- and full-court shot contests for charity?

 To watch an interview with a professional scan the QR code.

Telling a Story

There's no point in making a video if it isn't interesting and doesn't tell a story. This chapter will give you the tools to plan your story before you actually go out and shoot it. Defining objectives and a target audience, as well as making sure you have a clear vision of the story you're telling before you go out and shoot, will save you time, energy, and money in the end.

Storytelling is an ancient craft that predates writing. It has been around for centuries and has evolved over time. Today, contemporary storytelling can be seen in many media, including TV news stories, movies, films, videos, games, and commercials. Storytelling in videos is becoming increasingly popular, especially since the advent of social media such as YouTube in 2005. If you think about the videos that you like or that have gone viral, they most likely tell a good story. This chapter will focus on storytelling in video production and review techniques you can use to tell a good story.

People have forgotten how to tell a story. Stories don't have a middle or an end any more. They usually have a beginning that never stops beginning.
-Steven Spielberg

That's what we storytellers do. We restore order with imagination. We instill hope again and again and again.
-Walt Disney

Know Your Target Audience

A great story doesn't just happen—it's very carefully planned and crafted. There are many important steps you need to follow in order to tell a good story. The first step is to know your target audience.

Before you begin writing and shooting your story you need to know your audience. This means you need to identify and define the group of people for whom the video is aimed. As you learned in Chapter 1, identifying your target audience is part of the preproduction process. You might be tempted to think the whole world is your audience. However, the message or point of your video will be more effective if it is targeted to a particular group. Your audience could be an extremely small niche group or perhaps it could be a bit broader. The target audience is usually defined in terms of demographics and psychographics.

Examples of Demographics

- Gender
- Age
- Race
- Income

Examples of Psychographics

- Beliefs
- Values
- Attitudes
- Behaviors

For example, if you're making a video about the dangers of smoking, your message would be different if your target audience is teenagers, versus 40- to 60-year-olds. Target audiences may react differently to the same messages. A video that is humorous to teenagers may not be as funny to people who are middle-aged.

What's the Focus of Your Story?

Finding the focus of your story will enable you to tell a more compelling story. This may sound simple; however, you may be dealing with a complex issue or several related issues. You need to be able to find the focus of your story so you can tell the story in an easy-to-understand manner.

Finding the Focus

Here are several questions to help you find the focus.

You should be able to write what the focus of the story is in one simple sentence. For example, if you're covering a story on the presidential debates, you might focus on who won the debate by checking the facts each candidate presented. Alternatively, you may choose to focus on the audiences' reactions to the candidates' statements. Here are some questions you can ask yourself to help find your focus:

1. What is the main point?
2. Why should people care about this story?
3. Why does it matter to them?
4. Why do people want to know about it?
5. What do people need to know about the story?
6. Does this story deal with a larger trend or theme?
7. What's the conflict in the story?

"Tell-a-Friend or Tell-Your-Mom" Method

After you find the focus of the story, you need to think about how you are going to tell the story. A popular storytelling technique is to think about how you would tell the story to a friend … or even your mother. This helps you tell your story in a conversational manner. For example, when talking to a friend you probably will share only the most important and compelling details, leaving out the minor or uninteresting ones. The "tell-a-friend/tell-your-mom" method can help you organize your thoughts so you can tell a clear and compelling story.

More Formal: "Yesterday, company employees took self-appointed time off, went to West Philadelphia, and assisted the Habitat for Humanity Agency in restoring homes for those in need."

Tell-a-Friend Method: "Employees used their vacation time to help Habitat for Humanity build houses in West Philadephia."

Tell Your Story through People

The best stories are ones that people can relate to and that are personal. In order to do this, you need to put a human face on the story. For example, a video about homelessness is more compelling if you interview someone who is homeless and tell the story through his or her eyes. You will probably add important information such as statistics and facts, but people relate to other people. They like stories about real people. In fact, many advertisers and marketers use this technique to humanize their brand. The Dove Campaign for Real Beauty does this. This worldwide marketing campaign, which was launched by Unilever in 2004, features regular women instead of professional models. The ads tell the stories of real women and focuses on how beauty comes in all shapes, sizes, colors, and ages. Another example is the Always feminine care products commercial "Like a Girl" that first aired during the Super Bowl in 2015. The ad uses real people to show the differences in how women, boys, and young girls perceive the phrase, "like a girl." Procter & Gamble's Always commercial has an empowering message that demonstrates how women can lose their confidence in their teenage years.

5 Ws and H—Who, What, Where, When, Why, and How?

Many videos, but in particular news stories and documentaries, include answers to who, what, where, when, why, and how. The 5 Ws and H will help you make your story complete.

Another way to think about these questions are:

- **Who** was involved?
- **What** happened?
- **Where** did it take place?
- **When** did it take place?
- **Why** did it happen?
- **How** did it happen?

For example, if you're covering a story about a fire at a local elementary school you need to answer these questions:

- **Who** was involved? Who was in the building? Who was injured? Who was evacuated? Who started the fire?
- **What** happened? What caused the fire? What part of the building was damaged? What needed to be done to put out or contain the fire?
- **Where** did it take place? Where did the fire start? Where will classes be held?
- **When** did it take place? When was the fire noticed? When will it be safe to use the structure again?
- **Why** did it happen? Why did the fire start?
- **How** did it happen? How did the fire start? How long did it burn?

Write to the Video—Show, Don't Tell

Video production is a visual medium. Therefore, the best stories use the most compelling video footage to tell them. It is better to *show* your audience rather than just tell them. You've probably heard the expression "a picture is worth a thousand words." Well, this saying holds true for video as well. Visuals can have a greater impact than narration alone.

For example, if your video is about a ten-alarm fire then you need to show the massive flames and thick black smoke. You should provide visual proof for all the main points of your story. You also need to think about the best way to use video. Video is a good medium for showing action, emotion, and movement. However, it is not good for covering things that are not visually interesting or exciting such as meetings and court cases.

One thing you want to be careful *not* to do when writing a story is to "overscript." In other words, if you're doing

a story on cats, and you're showing a cat, you don't need to say "as you can see here, there's a cat …" Let the video speak for itself. It's important to strike a balance between saying enough about a story that your audience understands what you're trying to communicate, and allowing the images to speak for themselves.

Using Sequences to Tell Stories

As you learned in Chapter 3, sequences are a series of shots that feature the same subject and show a single action. When they are edited together they tell a story and create the illusion of continuous movement. A well-edited video sequence adds visual variety to storytelling. The best way to get a good sequence of shots is to shoot from different locations, angles, and distances. You should consider

getting at least four shots: a wide shot, a medium shot, and at least two close-up shots. In general you should not put two wide or medium shots in a row.

Some news stations and video production companies use this rule of thumb for shooting sequences as a reminder to make sure they're getting plenty of close-up shots:

"Wide, Tight, Tight, Tight."

To make sure you tell your story effectively, the number of shots for a single video gathering session should be approximately 25 percent wide shots, 25 percent medium shots, and 50 percent close-up shots.

THE FIVE-SHOT RULE

For video storytelling it is important to vary your shots. This includes varying their angles, distances, and settings. The Five-Shot Rule explains the five basic shots that can be used to give your video visual variety.

- A wide shot of where the story or main action is happening
- A medium shot of why it is happening
- Three close-up shots
 ◦ What is happening
 ◦ How it is happening
 ◦ Who is doing it

In addition to those five important shots, you'll also want to make sure you get the following:

- Extra shots
 ◦ An over-the-shoulder shot (OTS)—a medium shot linking the previous three concepts (e.g. close-ups of what is happening, how it is happening, and who is doing it)
 ◦ An unusual, or side/low angle shot—a medium or close-up shot showing details of the story

Using Sequences to Tell Stories: The Five-Shot Rule

Example: A Video of Girls Playing Basketball

- A wide shot of the basketball court
- A medium shot of two girls playing basketball
- Three close-up shots
 ◦ Close-up of girl's hand on basketball
 ◦ Close-up of girl's face
 ◦ Close-up of girl's feet
- Extra Shots
 ◦ An over-the-shoulder shot (OTS)—a shot of one of the children taken from the perspective or camera angle from the shoulder of the other child. The back of the shoulder and head of the first child is used to frame the image of the other child the camera is pointing toward.
 ◦ An interesting shot, such as a low-angle or high-angle shot. You'll learn more about these shots in Chapter 6. In a high-angle shot the camera is placed above the subject and angled down toward the subject. This can make the subject appear less powerful. A low-angle shot looks up toward the

Wide shot of the basketball court

A medium shot of two girls playing basketball

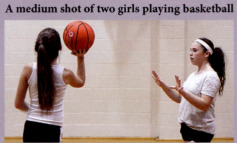

Close-up of girl's hand on basketball

Close-up of girl's face

Close-up of girl's feet

An OTS

A low-angle shot

subject and is shot from below the subject. It can give the subject the appearance of being more powerful. For example, you could take a low-angle shot of the girl shooting a basket.

Please Note: Sometimes rules are made to be broken. Each story should be handled on an individual basis. For example, sometimes a close-up shot to start a sequence can grab viewers' attention and bring them into a story more effecively than starting with a wide shot.

Use Sound—Get Good Clean Sound; Short Compelling Sound Bites; and Nat (Natural) Sound

Audio is an important part of your video.

GOOD CLEAN SOUND

You want to make sure that you capture clean sound. It's almost impossible to clean up poor sound. A good lavaliere microphone or shotgun microphone on a boom pole are good ways to get clean sound, because they capture the sound coming out of a person's mouth. Three common things you need to watch for are wind, echoes, and air conditioning noise. These can ruin your sound. As you learned in Chapter 4, a foam piece called a *windscreen* can be placed on a microphone to help reduce unwanted wind or breath noises. Another trick is to angle subjects so the wind is blowing against their backs and the subjects' bodies act as windbreakers. If a noisy air conditioner is a problem, and you are shooting inside, make sure not to directly position a subject under or next to a vent. You also want to be careful about echoes coming off of hard surfaces.

SHORT, COMPELLING SOUND BITES

When interviewing someone for a story the best way to get compelling sound bites is to ask good questions. A sound bite is a short excerpt from an interview that is usually about 5 to 15 seconds. A good way to get great sound bites is to listen carefully to your subject so you can ask pertinent follow-up questions. When choosing sound bites you want to pick out

the portion of the interview that answers the question, "Why would viewers care about this, or so what?" Often the ideal sound bite expresses emotion over an issue, event, or situation.

NAT SOUND

As mentioned in Chapter 4, *nat sound* refers to natural sound that is produced or exists in the environment in which you are shooting. It is the audio portion of the video image that viewers see on the screen. In terms of storytelling, nat sound is often used in a video to capture viewers' attention. It is sometimes used in the beginning of a video along with a lead or hook. It can also be used at the end of a story so that it concludes memorably. Further, nat sound can be used throughout a story. It is very powerful and helps put the viewer at the scene of the video. For example, if you're doing a story about opening day of the baseball season for a local minor league team, the nat sound could include the ball hitting the bat, the crowd singing "Take Me Out to the Ballgame," and the food vendor who is selling popcorn and peanuts yelling to the crowd.

Nat Sound Storytelling Tips

- Record audio along with your video. Make sure you're recording audio when you shoot all of your video.
- Be on the lookout for sounds to include in your video. You should always be aware of the sound in the environment and how it will help you tell a story. You might have to get your microphone very close to the sound you want to include.
- Layer nat sound with interview sound bites or voice-overs. A voice-over is when the talent's voice is heard behind the video. This video usually illustrates what the talent is talking about, but you don't see the talent. You can use nat sound underneath sound bites or voice-overs at a lower volume to add depth to your story. Combining all of these kinds of sounds helps create a more interesting story and helps the viewer feel more immersed in the story. You can even combine nat sound with music.

Keep Your Story As Short As Possible

In our fast-paced multimedia world, people often have short attention spans. Therefore, a video should be as short as it can be and still tell a good story. The length of a television news story by a reporter in a newscast is usually 90 seconds. Many tutorials on the Internet are under two minutes. Television and Internet commercials are most often 15 to 60 seconds.

A STRONG OPEN AND CLOSE

Most stories have a beginning, middle, and end. The middle of the story usually has several clear and concise points that are supported through visuals. While the middle of the story is important, people remember what they see and hear first and last the best, so make sure that both the beginning and end of your story are strong. For example, a story about a fire in an apartment building could start with a sound bite of someone saying, "I lost everything in the fire." This will get people's attention and entice them to watch the story. You might also consider starting that story with video of towering flames and nat sound of fire engines at the scene. When ending a story, it's often a good idea to use a great image and/or sound bite. For example, a story about a fundraiser for the Humane League could end with a close-up of a puppy's face. The story could also end with a short sound bite of someone talking about how adopting a puppy has changed his or her life.

Tools to Plan Your Story

Scripts and storyboards are tools to help you tell great stories. They are important in assisting and preparing the crew and talent for the production.

SCRIPTING

A script is a guide or an outline for the visual telling of the story or event. It is written before the production.

The script includes items such as:

- Characters/actors
- Dialog or voice-overs
- Camera shots
- Sound effects
- Graphics
- Lighting
- Locations
- Music

There are different types of scripts for different types of productions. A one-column script is most often used for dramas, while a two-column script is used for news and documentary productions.

One-Column Scripts

A one-column or single-column script is most often used in dramas in the television and film industry. It includes the location of each scene, dialog, actor delivery cues, and descriptions of the actions that take place. This kind of script does not indicate individual camera shots or moves. The basic format is as follows: Spoken dialog is usually in both lower and uppercase, along with character delivery cues like "angry" or "crying," which are in parentheses or brackets. Names of all characters or actors are in capital letters along with audio cues.

Format for One-Column Scripts

- From margin to margin include scene descriptions and camera direction.
- In a three-inch wide column down the center of the page write the dialog.
- In all caps give the name of the actor and center it just above his or her speech. Place delivery instructions in parentheses, on a separate line, and indented within the column of the speech.
- Also in all caps include transitions, location descriptions, and camera directions.
- Everything else is in upper and lowercase, including dialog and character delivery cues.
 - Single-space material such as dialog and scene descriptions.

See **Appendix 1** at the end of this chapter for a sample one-column script.

Two-Column Scripts

Two-column scripts are often used for informational video productions such as newscasts and documentaries. The left column contains all the shot descriptions, production information, and directions. This information includes all of the video cues, like which anchor is on-camera, camera shots, news story information such as a VO (voice-over, where the talent reads copy live while video is playing) or SOT (sound on tape, when a short clip shows someone who's been interviewed talking on camera) and CG (character generator copy, often location, names, or titles of people). The right column contains the audio information, like the words spoken by anchors or narrators. It can also include the out cues (the last few words of recorded segments) as well as descriptions of music and sound effects. Often, copy that is spoken by the anchors is in all capital letters.

Format for Two-Column Scripts

- Left column (single-spaced): video elements.
- Right column (double-spaced): audio elements.
- Upper and lowercase: video descriptions, sound bites, spoken copy in documentary scripts.
- All caps: camera directions, location descriptions, transitions, and music. (Spoken copy is often all caps, but sometimes it is upper and lowercase.)

See **Appendix 2** at the end of this chapter for an example of a two-column news script.

A two-column documentary script is often used for nondramatic shows such as live talk shows. The left column contains all the video information, and the right column lists all the audio information.

See **Appendix 3** for a sample documentary script and **Appendix 4** for a sample in-studio production script.

STORYBOARDING

A storyboard serves as a visual representation of the shots in your production. It is done before you begin shooting. A video can include many different elements, like video footage of specific shots, audio, music, and graphics. You need to think about all of these elements when creating your storyboard. For your storyboards draw specific shots that you want in your video. Storyboarding helps you to visualize your story before you go out and shoot it. It helps you think about what shots you will need to complete your video. Your storyboard

may change many times as you plan your video. You want to make sure your storyboards are as complete as possible before you start to shoot. However, sometimes changes occur after you go into the field and shoot your footage and interviews.

There are several types of storyboards. Often they are boxes with brief descriptions and very basic drawings. They can be hand drawn or computer generated. Most are simple black and white line drawings, but they can also be color illustrations or even animated. There are many software tools on the market to help you make a storyboard. They often range from free to about $1,000, depending on their complexity. One example of freeware is Atomic Learning's StoryBoard Pro.

Storyboarding Steps

1. Break down your script by highlighting all the aspects of your video, including specific shots, audio, music, and graphics.

2. Examine all of the main events in the story. Think about how they will appear in the video. Decide what the key images or scenes in your story will be.

3. Make a shot sheet or shot list by deciding how each shot will look. You need to think about the location setting, how many people are in the shot, the type of shot, the shot's angle, the lighting in the shot, any camera movement in the shot, whether you will need any special microphones for the shot, and so on. There are many shot sheet and shot list templates that are readily available on the Internet to download for free. See **Appendix 5** for an example of a simple shot sheet/shot list to accompany the script in Appendix 1.

4. Create storyboard panels. The easiest and quickest way to create these is to take a blank piece of paper and fold it in half four times then unfold it to get eight panels. You can now sketch up to 16 panels using the front and back of the sheet. You can also draw your own panels by making four to six on an 8-½ × 11 piece of paper. Another option is to buy pads of storyboard panels. You can also use storyboard software for templates.

5. Draw each shot and write a brief description of the illustration in a text box at the bottom of each panel. This text box can include the type of shot it is (LS, MS, CU, etc.), camera directions/movements, lighting concerns, special audio instructions, and other information.

Example: College Student Racecar Driver Storyboard

Here's a rough storyboard for a video about a college student, Jane Smith, who is also a professional racecar driver.

Video: Anticipate video from two locations: Smith's college and the racetrack. First location—Smith on her university campus walking around, in her dorm, and in classes. Second location—at the racetrack practicing before an actual race, and then video of her during the race.

Audio: Anticipate audio from the field: Smith explaining how she became a racecar driver, what it's like, and why she does it. Nat sound from the racetrack. Also nat sound of her talking in class to her professor.

Still photos: Photos of her growing up on the racetrack with her father, a former racecar driver, and photos of her with winning trophies from previous races.

Graphics: News clippings of Jane Smith from newspapers.

Sample of a Rough Storyboard

Opening shot: Jane Smith winning her last race.

Jane's childhood: Video of Jane growing up on the racetrack with her father.

Jane's racing story: Jane being interviewed by a reporter about why she races cars.

Jane's schooling: Jane's college graduation receiving her degree in mechanical engineering.

Closing shot: Jane daydreaming about winning the Indianapolis 500.

Storytelling Checklist

FOLLOW THESE 8 STEPS TO MAKE SURE YOU'RE READY TO TELL A GREAT STORY

Step 1: Target Audience

Have you identified your target audience? If so, you're ready to move to Step 2. If not, you need to think about who, specifically, you're targeting your message to.

Step 2: Story Focus

Have you found a focus for your story? If so, move to Step 3. If not, you need to make sure you have a clear idea of what your story will be about. To find your focus it's helpful if you can tell your story in one simple sentence.

Step 3: Personalize the Story

Have you found a way to tell your story through people? If so, move to Step 4. If not, find a way to put a human face on the story.

Step 4: 5 Ws and H

Have you included the who, what, where, when, why, and how of your story? If so, move to Step 5. If not, in most cases you'll need to make sure you get answers to these questions so your story is complete.

Step 5: Show, Don't Tell

Have you crafted your story in such a way that you allow your compelling video to tell the story? If so, move to Step 6. If not, think about ways you can use your video to *show* what's going on, as opposed to telling your viewer what's happening. Remember, a picture is worth a thousand words.

Step 6: Strong Open and Close

Have you thought about how you will open and close your story? If so, move to Step 7. If not, think about images and sound bites that will be compelling. Use these compelling images and sound bites to begin and end your story.

Step 7: Scripting Format

Have you written your script in the proper format? If so, move to Step 8. If not, write your script in the proper format so there's no confusion when you're shooting.

The man in black shoots open a second-story window, climbs on a Dumpster, and jumps through a dark warehouse.

The officer sprints down the alley with flashlight and gun drawn, and follows him through the warehouse window.

INT. WAREHOUSE – NIGHT

 OFFICER
 Police! Drop your weapon and
 put your hands in the air!

 MAN IN BLACK
 (Laughing) Do you really
 think you're going to stop me?

 OFFICER
 Don't move, or I'll shoot!

 MAN IN BLACK
 If you want me, come and get me.

The man in black disappears behind a tall row of steel cylinders and cranks open a valve on one of them. Pressurized gas HISSES out.

...officer curses and looks for another way around. ... forklift and jumps to a high shelf ...le at the man in black, who ...

Step 8: Storyboarding

Have you prepared storyboards? If not, make storyboards for your production. Storyboards will help you visualize your production before you shoot it. The more detailed your storyboards are, the less likely you are to miss getting an important shot.

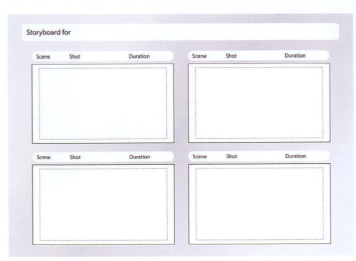

Activities—Put Your Learning into Action!

1. Go online and watch several videos that are trending. What elements of storytelling do these include? Who's the target audience? Do the videos have a beginning, middle, and end? What about a strong opening and close? How long are the videos?

2. Watch some commercials from the most recent SuperBowl. What storytelling elements do they use?

3. Watch local TV news. What storytelling techniques do the reporters use? Are they different for the various types of news stories?

4. A local university asked you to make a video to recruit new students. What would be a good open and close? What points would you include in the middle? What nat sound would you add?

5. Think of a recent vacation or excursion you took. How would you create a video about it? On paper outline what parts you would include. What nat sound would you add? What visuals would best help you tell your vacation story? What would be your open? Your close? What points would you include in the middle?

6. Practice storyboarding by taking a newspaper feature story and sketching out all of the elements in it. Think about how you would tell this story visually. It is best to identify the 5 Ws and H (who, what, where, when, why, and how) before you start. Allow those elements to help you develop your storyboard.

7. Practice scripting by taking a newspaper story and writing it as a two-column script. Try this exercise first with a hard news story (serious news such as crimes, politics, business, foreign affairs) and then a soft news story (feature and human-interest stories). Identify the 5 Ws and H before you start writing the script. Compare the script for the hard news and feature stories.

8. **Service-Learning Activity**: Watch a couple of public service announcements (PSAs). Who is the target audience? What techniques do the videos use to grab the attention of the target audience and get them to care about the cause or agency? Do the videos create awareness, give information, educate about a problem, and/or persuade the audience to take action?

To watch an interview with a professional scan the QR code.

Appendix 1: Sample One-Column Script

SAMPLE ONE-COLUMN SCRIPT

SCENE 1

AN ITALIAN RESTAURANT

A husband and wife are walking into a restaurant. The wife thinks she is going to a work function for her husband.

RACHEL

I hope I am dressed appropriately for the party tonight.

BEN

Honey, you look great.

RACHEL

(inquisitively)

Is anyone going to be here that I know?

BEN

(mutters under his breath)

Oh, I think you will know more people than you realize.

RACHEL

(about to open the door to the back room in the restaurant)

What did you say? I didn't hear you.

PARTY GUESTS

(yelling)

Surprise!

BEN

(smiling)

Happy Birthday Rachel!

RACHEL

(speechless and crying, she kisses her husband)

Appendix 2: Sample News Script

2-SHOT-2	{SUSAN ON 2}
CG: SUSAN SMITH	FINALLY THIS EVENING … TODAY IS READ ACROSS AMERICA DAY, DESIGNED TO CELEBRATE THE BIRTHDAY OF DOCTOR SEUSS.
VO NATS TAKE TAPE	{**BILL VO**} STUDENTS AT GEORGE WASHINGTON ELEMENTARY SCHOOL IN WILLIAMS COUNTY CELEBRATED BY MARCHING OUT ONTO THE SCHOOL'S SOCCER FIELD AND FORMING A POPULAR DOCTOR SEUSS SYMBOL. THEY USED CARDS TO FORM THE RED AND WHITE HAT WORN BY THE CAT-IN-THE-HAT.
SOT TAKE TAPE— CG: Rachel Cassidy\Third-Grader Length: 0:09	{**SOT**} <I really enjoy Doctor Seuss books because they rhyme and have a good moral lesson.> {VO PAD}
OUT CUE—MORAL LESSON	THE STUDENTS IN KINDERGARTEN AND FIRST GRADE WERE EACH GIVEN A DOCTOR SEUSS BOOK … THANKS TO A GENEROUS DONATION FROM KING'S GROCERY STORE.

Appendix 3: Sample Documentary Script

BAKING Series

Program No. 1: Decorating Cakes

VIDEO	AUDIO
VTR standard opening	SOT
Danielle on camera	DANIELLE Hi, I'm Danielle from Classic Bakery and I am going to demonstrate how to decorate a cake using fondant. It's sort of like playing with clay … remember that from your childhood? You can roll it, cut it, and form it into about any shape. You can also create cool designs. Earlier I made some neat fondant creations. Let's take a look at this clip.
Key titles	My favorite is the flower. Let me show you how to make one.

Appendix 4: Sample Two-Column In-Studio Production Script

MEET A STUDENT	Sally Smith	1/27/16

(FULLSCREEN "Meet a Student")	(THEME MUSIC UP, THEN UNDER)
(MS HOST ON 3)	Host: Welcome to "Meet a Student" a daily feature on E-C-T-V-40. I'm your host Jill Johnson, and today
(MS GUEST/HOST ON 2)	I'll be talking to Sean Miller and Chris Jones. Welcome to the show … and tell us a little bit about yourselves… .
(MS GUESTS ON 1)	(guests ad lib)
(MS HOST/GUESTS 2)	(host ad libs questions)
(MS GUESTS ON 1)	(guest ad libs answers)
(MS HOST ON 3)	Host: That's about all the time we have for today … please join me again tomorrow when we will meet another student.
(FULLSCREEN "Meet a Student")	(THEME MUSIC UP, OUT AT 2:00)

Appendix 5: Sample Shot List

Note: This shot list corresponds to Appendix 1: Sample One-Column Script.

Scene #	Shot #	Shot Type	Storyboard Shot #	Location	Shot Description	Duration
1	1	LS or WS	1	Italian Restaurant	Husband and wife walking into a restaurant	:10
1	2	MS	2	Italian Restaurant	Rachel looking at her outfit and smoothing her dress	:05
1	3	CU	3	Italian Restaurant	Rachel's hand fixing her dress	:03
1	4	CU	4	Italian Restaurant	Ben looking at Rachel's outfit	:03
1	5	CU	5	Italian Restaurant	Rachel's hand opening the door to the back room in the restaurant	:05
1	6	MS	6	Italian Restaurant	Party guests yelling "Surprise!"	:07
1	7	OTS	7	Italian Restaurant	Ben looking at Rachel	:05
1	8	CU	8	Italian Restaurant	Rachel crying	:05
1	9	MS	9	Italian Restaurant	Rachel and Ben kissing	:08

Shooting Video and Field Production

Once you have thoroughly planned your story, it's time to go and shoot. This chapter outlines basic techniques for framing shots and emphasizes the importance of getting a variety of shots to make sure the editing process goes smoothly. Tips for shooting in the field and in preparation for editing will also be highlighted.

Cinema is a matter of what's in the frame and what's out.
-Martin Scorsese

Photography is truth. The cinema is truth twenty-four times per second.
-Jean-Luc Godard

The Tripod

The first and best advice for making your video look professional is to use a tripod. It will help you control your video camera, keep your shots steady, and allow for smooth pans and tilts. We have all seen video that is shaky or moving in and out of focus. It's very distracting and often the first thing that comes to mind is "amateur." You should use a tripod whenever possible. It takes a few extra seconds to set up, but it makes a big difference in the long run. Tripods come in a variety of models at different price points. The following is a list of the common features of most tripods.

Parts of a Tripod

Mounting head:
Mounts to your video camera and allows it to pan and tilt. Also, provides resistance and lock mechanisms so your camera stays put when you let go. True fluid heads allow for the smoothest moves and help alleviate jerky, uneven movements.

Legs:
Extend and then lock into place. The strength of a tripod is gauged by the amount of weight it is rated to hold. It is a good idea to pick a tripod that is light enough for you to carry but still sturdy enough to support your camera.

Quick release plate:
Also called the *wedge mount*. It allows you to remove the camera from the tripod quickly without having to rebalance its weight on the mounting head.

Bubble:
Most tripods have a bubble that acts as a level, to help you level the tripod.

Feet:
Rubber cups and/or spikes that grip the ground without slipping. This will help you anchor your shots. The spikes are often under retractable rubber covers for shooting outside on the ground, while rubber cups help prevent it from slipping on smooth surfaces.

Spreader:
A spreader is found on more professional tripods. It is a device found at the base of a tripod with three arms joined together, which lock in place to prevent the legs from collapsing.

TRIPOD TIPS

The following are some tips and techniques for successfully using your tripod to shoot great looking video.

Level Your Head

Adjust the height of each leg until the bubble is centered in the target. You may be on a slightly uneven surface, and the legs may need to be different heights to make the head level. Some tripods have independent leveling mechanisms so you do not have to perfectly adjust the legs of the tripod to be level.

Find Your Optimal Height

Depending on what you are shooting, make sure your tripod legs are extended high enough to see your subject at eye level. Many tripods have a center column that enables you to crank the camera even higher. However, using the legs to get higher will offer more support to the camera than simply using the center column.

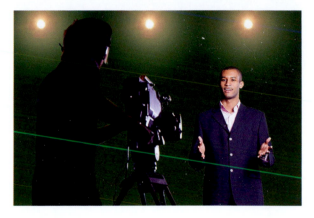

 Scan the QR code to see the difference a tripod can make when shooting video.

Adjust the Tension

In order for pans and tilts to be smooth you need to adjust the resistance known as the *drag*. The drag should not be too loose or too tight. The pan and tilt drags are adjusted separately. You can even lock the tilt but still pan and vice versa.

Move Slowly, Smoothly, and Steadily

Making sure your movements are slow, smooth, and steady is especially important when panning and tilting. This takes practice. Also, it is helpful to know where you want to start your shot and where you want it to end.

Composition and Framing

Composition and framing are important elements of shooting good video. There are several key concepts that can help you achieve framing that is pleasing to the eye.

BALANCE

Balance refers to having symmetry and asymmetry in your composition. Symmetrical balance is when you place your main object or subject in the center of your shot. This can create formal shots and is often used for establishing shots of grand buildings or structures such as the Eiffel Tower in Paris. Asymmetrical balance is often used to create a more interesting or dynamic composition. A main subject is often balanced by a smaller or less significant object. The main subject is placed off-center. Asymmetrical balance often follows a technique called the *rule of thirds* (see next technique). It is a good idea to use both symmetrical and asymmetrical balance in your composition of shots for more interesting videos.

Symmetrical Balance

Asymmetrical Balance

RULE OF THIRDS

The best way to envision the rule of thirds is to imagine your screen divided horizontally and vertically into thirds or nine equal parts, by two equally spaced horizontal lines and two equally spaced vertical lines. The placement of a subject or element is often more dynamic and interesting if it is asymmetrical. Therefore, objects should be placed along these lines or their intersections. For example, if you're interviewing someone, he or she should be placed in the first or third sections of your screen rather than the center.

Rule of Thirds

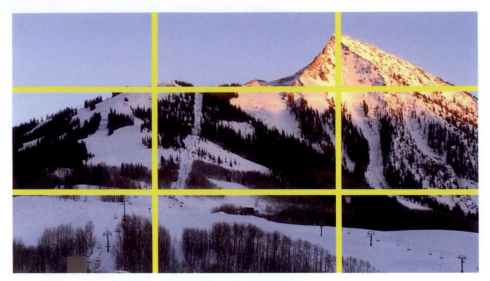

HEADROOM

Along with positioning a person according to the rule of thirds, you also want to make sure that a person or object does not touch the upper screen edge or the top of the frame. You need to leave an appropriate amount of space, which is called *headroom*. Correct headroom places the eyes of the person in the upper third of the screen. It is important not to leave too little or too much headroom. Too little headroom can make the subject look cramped, and too much can make your subject looked dwarfed.

Too little headroom.

Too much headroom.

Correct headroom.

NOSEROOM

This framing concept goes hand in hand with headroom and is used when you're composing a profile shot of a person. You need to give a person the proper noseroom in front of his or her nose. *Noseroom* refers to the space between a person's nose and the screen edge. For example, too little noseroom and it looks like the person is crashing into the edge of the screen. As you can see in the figures it is still important to place the subject according to the rule of thirds.

Too little noseroom.

Too much noseroom.

Correct noseroom.

LEADROOM

This technique is helpful when shooting moving subjects. If a person, animal, or object is moving laterally across the screen, it is important to leave space in the direction the subject is moving. This refers to *leadroom*. It can be tricky to shoot the proper leadroom because the subject is moving. You should try to shoot somewhat ahead of the subject's movement. For example, when shooting people running, too little leadroom makes it look like the runners are going to hit the screen's edge. Proper leadroom allows the viewer to see where the runners are going and will keep the audience looking forward.

Too little leadroom.

Correct leadroom.

FRAME WITHIN A FRAME

Another way to draw attention to or highlight your subject is to place them in a frame. When you're shooting you can look around for natural or manmade objects that can serve as frames, such as bridges, doors, archways, trees, picture frames, or other objects. It's often a good idea to make sure the framing element is not too distracting.

 Scan the QR code to see composition and framing tips.

CUTAWAYS

These shots usually take your viewer away from the main action but still relate to the main action in the shot. This might include shots of another action or object in the same location. Cutaways are often used during editing to add shot variety and avoid jump cuts. You'll learn more about jump cuts later in the chapter. It is important when you're out in the field to anticipate what cutaway shots will be needed. It is difficult to edit long sequences of shots together if you don't have enough cutaways. For example, if the main subject is a girl cheerleading during a high school football game, possible cutaways could be a shot of her parents watching her from the stands, the band on the field, or a vendor walking around selling popcorn. In the photo on page 100, a cameraman is shooting subjects in the sea. Cutaway shots would include close-up shots of lifeguards, sunbathers on the beach, and people walking on the boardwalk.

Cameraman shooting cutaways of people in the water.

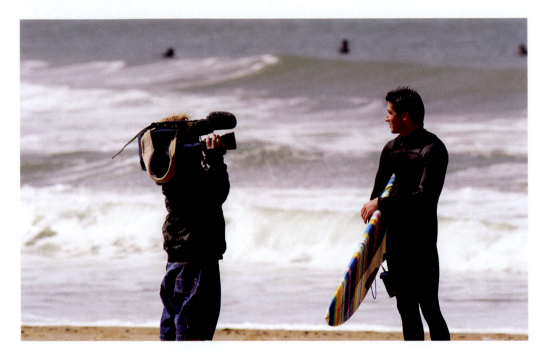

 Scan the QR code to see examples of cutaway shots.

JUMP CUTS

A jump cut occurs when two sequential shots of the same subject, from practically the same camera position, are shown one after another. This type of edit gives the effect of jumping forward in time and is usually undesirable. In order to avoid jump cuts most editing uses a guideline called the *30-degree rule*. In order for consecutive shots to appear "seamless," this rule advises that the camera position must vary at least 30 degrees from its previous position. Another way to avoid jump cuts is to use cutaway shots, as you learned earlier. An example of a jump cut would be if you edited together two consecutive, almost identical shots of a person who was being interviewed by a reporter. In order to avoid a jump cut you could insert a cutaway of the reporter, a close-up of the subject's hands, or perhaps video of what the subject was discussing in the interview.

Jump cuts also occur when the subject of your action appears to jump from location to location, or disappear, as if by

magic. For example, if you're shooting video of a student standing in a hallway and then in the very next shot that same student is sitting in a lounge—that's a jump cut.

Scan the QR code to see examples of jump cuts.

BACKGROUNDS

Determining the background for your video will have an impact on how your story is told. Strategically choosing where you shoot your video and what's in the background can save you a lot of time. The following are important points to remember.

- Keep in mind a natural backdrop can be better than an artificial one like a green screen or black curtain. Often, seeing people in their natural environment makes the video look more authentic.

This would be a good background to use if you're shooting a video about college life because it shows the student on a college campus.

- Avoid backgrounds that don't look interesting, aren't important to the story, or are distracting with lots of movement. You want to keep the focus on the person or subject, and away from what's happening behind him or her.

This is not a good background because it looks like a tree is growing out of the subject's head.

A plain white wall is a boring background.

- If you're shooting multiple people using the same background, try to change the angle at which you're shooting each person on the background. Also, for each person you are interviewing alternate the way he or she faces the camera. For example, if one subject is facing to the left of the camera the next should face the right. This helps create visual variety in your video.

Pictures to demonstrate alternating the way the talent faces.

- Create space between the subject and background, especially in interview situations. When subjects cast shadows, their shadows can be a distraction on the wall behind them if they are too close. Move them away from a vertical surface and the shadow will disappear. Also, if subjects are too close to the background the shot can have a flat look to it and lack depth.

 Scan the QR code to see examples of visually appropriate and inappropriate backgrounds.

Shots That Help Tell the Story

When making a video you need a variety of shots to help tell a story. You want to make sure you shoot enough b-roll—video that's used over narration and interviews. When used effectively, b-roll illustrates what an interviewee is saying or what the talent is talking about. In Chapter 5 you learned about the Five-Shot Rule: wide shot, medium shot, and three close-up shots. Here are some other shots you can include to help tell your story in a visually interesting way.

Exterior Shot: A shot that is taken outdoors. Often establishing shots that are taken outdoors are also called exterior shots.

Point of View (POV) Shot: A shot from the perspective of the subject.

Reverse-Angle Shot: A shot where the camera is placed in the opposite position (usually 180 degrees) from the previous shot.

High-Angle Shot: In a high-angle shot the camera is placed above the subject and angled down toward the subject. This can make the subject appear less powerful.

Low-Angle Shot: In a low-angle shot the camera is placed below the subject and is angled up toward the subject. This can give the subject the appearance of being more powerful.

Interior Shot: A shot that is taken indoors. Often establishing shots that are taken indoors are also called interior shots.

Establishing Shot: The first shot of a new scene. It establishes where and when the scene or action takes place. It is usually a wide shot or an extreme wide shot.

Insert Shot: A shot showing detail, usually a close-up shot.

Reestablishing Shot: A shot that again establishes where and when the action takes place, but it is used near the end of a video.

Transition Shot: A shot that transitions to another scene or action.

Reaction Shot: A shot that shows the reaction of a character or characters to the preceding shot.

Exterior vs. Interior Shooting

When shooting you also need to consider whether you will shoot your video outdoors or indoors. Each has its own set of concerns and considerations.

OUTDOORS

If you shoot outdoors you have to be prepared for the weather.

- Rain and snow can damage equipment.
- There can be audio interference from wind or vehicles driving by.
- Extreme cold can cause problems with your video camera, especially when you go from shooting outdoors to indoors. It may take a few minutes for your camera to warm up.

- Weather conditions that change from cloudy to sunny might interfere with the continuity of your video and even make your video look like it contains jump cuts.

- Consider the direction of your shots with respect to the sun. Do you see shadows? If so, you might want to position your talent and/or camera in a different location. Are you shooting directly into the sun? If so, this can cause poor exposure.

INDOORS

If you are shooting indoors you might have to rearrange a room to get a visually pleasing shot.

- Look around the room and remove any distracting items. For example, you might need to remove a plant, clean up a messy desk, or reposition furniture.

- Close blinds or shades to get optimal lighting.

- Be mindful of a noisy air conditioner, as it could cause unwanted sounds when recording your audio.

- If there are people in the room, you might need to ask them nicely to be quiet while you record.

Shooting Video and Field Production Checklist

FOLLOW THESE 6 STEPS TO SHOOT GREAT VIDEO

Step 1: Use a Tripod

Have you properly set up your tripod? If so, you're ready to move to Step 2. If not, you need to make sure that your tripod is balanced and set to the proper height for your subject.

Step 2: Think about Composition and Framing

Have you framed your shot using either asymmetrical or symmetrical balance? If so, move to Step 3. If not, think about the purpose of the shot. For some shots, symmetrical balance will work well, but for others you should use asymmetrical balance by following the rule of thirds. Also, make sure to leave both proper headroom and noseroom for your subject.

Step 3: Get Cutaway Shots

Have you shot enough cutaways so you won't have jump cuts when editing? If so, move to Step 4. If not, make sure to get enough shots away from the main action. Remember, cutaway shots still need to relate in some way to the main action in the shot.

Step 4: Shots That Tell a Story

Did you get some shots that help tell a story? If so, move to Step 5. If not, consider getting point of view, insert, reverse-angle, transition, and high- and low-angle shots. These will add visual variety to your storytelling.

Step 5: Think about the Background

Have you determined the best background for your shoot? If so, move to Step 6. If not, find a good background that won't be too distracting and that will keep the focus on the person or subject.

Step 6: Shoot Location

Have you thought about where you will shoot? If not, think about whether you will shoot inside or outside and how you can best prepare for each. If shooting outside, you'll want to think about things like the time of day you're shooting and the weather conditions. If you're shooting inside, you'll want to make sure you look around the room and make any changes to prepare for your shoot.

Activities—Put Your Learning into Action!

1. Watch a movie or television show and tally the number of shots that use symmetrical balance versus asymmetrical balance.

2. Watch the news and notice how many shots in a news story use the rule of thirds.

3. Practice shooting and interviewing friends or family members by making sure they have the proper headroom and noseroom.

4. Take your video camera outside and practice using the technique of leadroom by shooting cars going down your street or planes flying in the sky. When shooting this video, what weather factors do you need to take into consideration?

5. At your next family event such as a birthday party or a holiday dinner, practice shooting cutaways. What would your cutaways include? How would they help you avoid jump cuts when editing the video?

6. **Service-Learning Activity**: Watch the public service announcement (PSA) *Sand Box* (https://www.youtube.com/watch?v=i2iG9NQk9mI) for The Shelter Pet Project (theshelterpetproject.org). Do you think a tripod was used when shooting the video? Identify the sequence of shots. Which shot framing and composition techniques are used? Are a variety of shots used? Are there shots that help tell the story? Is the background appropriate for the video?

To watch an interview with a professional scan the QR code.

Nonlinear Editing

Editing is an important part of the storytelling process. It goes beyond just knowing which buttons to press on a computer. Instead, great editors understand how to take the video that's been recorded and put the individual shots together in a way that creates a compelling and emotional experience for the audience. Before you sit down to edit there are some important terms you need to know in order to understand the editing process.

Film editing is now something almost everyone can do at a simple level and enjoy it, but to take it to a higher level requires the same dedication and persistence that any art form does.
-Walter Murch

Drama is life with the dull bits cut out.
-Alfred Hitchcock

Time Code

While recording video, you're recording more than just images—you're also recording something called time code, also referred to as SMPTE (simp-TEE) time code. SMPTE stands for Society of Motion Picture and Television Engineers. Time code is a series of electronic pulses that record the hour, minute, second, and frame that each image is recorded. Here's what time code looks like when you're recording video.

This time code, located on the camera's flip-out viewfinder, is telling us that the video we're looking at was recorded at 2 hours, 1 minute, 42 seconds, and 0 frames.

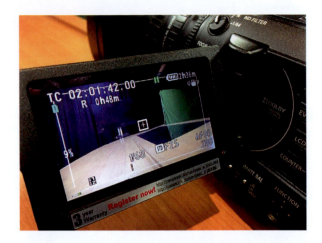

You also use hours, minutes, seconds, and frames when you're editing video. This is an example of one way that hours, minutes, seconds, and frames are used in the editing program Adobe Premiere. Here you can see that the piece of video being edited is at 0 hours, 1 minute, 22 seconds, and 6 frames.

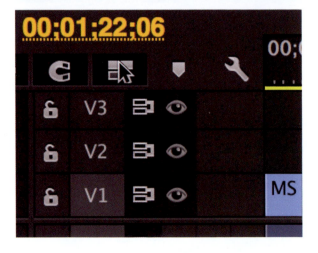

WHAT IS A FRAME?

You already know what hours, minutes, and seconds are, but how about frames? Frames represent each individual image that your video camera is recording. Moving video is nothing more than a series of individual still pictures passing very quickly in front of your eyes. They move so quickly that when you see each of these individual pictures in rapid succession they appear to move. Here's an example of a series of frames taken from a video of someone skiing.

FRAME RATE

There are 60 minutes in a hour, and 60 seconds in a minute, but how many frames are there in one second of video? Well, it depends. Many cameras will record at 30 frames per second (fps). This means that the camera shoots 30 frames (individual pictures of the action) to make up one second of video. You can set some cameras to record more or fewer frames per second. The fewer frames per second you record, the less sharp the image will look to the viewer. Many films are shot at a rate of 24 frames per second, because filmmakers like the look of the slower frame rate. At the other end of the spectrum, some videos are shot at a rate of 60 frames per second, although there is considerable debate over whether the human eye can detect differences in the video once the frame rate moves beyond 30 frames per second. If you are planning to use slow motion shots in your video, you'll want to make sure you're recording more frames per second so when you slow the shots down they won't look blurry.

You can think of frames as each individual page in a newspaper. Without the individual pages, you wouldn't have the entire paper.

Logging Video

Before you begin editing you'll want to make sure you log your video. This process involves watching your video and then writing down a description of each shot, how long it runs, and its time code. This process can often be time-consuming, and you may be tempted to skip it and just move straight to editing, but logging your video will actually save time in the long run. For example, if you've shot two hours of video for a story that will be one minute long, that means there's a lot of video that you aren't going to use. To ensure you're using the best shots and interviews you gathered, and to make sure your script and video match, you'll want to log your video.

Here's an example of a project that's being logged. Take note that each shot contains a time code of where the shot can be found, a description (whether it's a CU, MS, LS, etc.), and how long the shot runs. It's helpful to put a star next to shots that you really like; that way you won't accidentally forget about them.

Timecode	Shot Description	Length
0:00:30:00	LS of tree	:15
0:01:02:00	MS of tree	:12
0:02:00:00	CU of tree	:14
*0:03:25:00	CU of nest	:16
0:04:01:00	CU of leaf	:10

LOGGING INTERVIEWS

When you're logging an interview that you've shot, it's a good idea to transcribe what the person said if you think you'll use the sound bite. Here's an example of what a log of a recorded interview might look like. Again, it will save you time later if you put a star next to any great sound bites.

Timecode	Soundbite
0:00:45:00 – 0:00:52:00	"This is an amazing event and I'm so happy we had so many people come to help raise money to fight this awful disease."
0:02:03:00 – 0:02:09:00	"I'm overwhelmed by the amount of support I've received."

 To see an example of how video is logged scan the QR code.

Editing

Once you've shot, watched, and logged your video, and you have your script in hand, it's time to edit! You should resist the strong temptation to jump into the editing process too quickly. Make sure you have a plan for which shots you want to put where, how music will be used, and how you will use any special effects and graphics. Once you have this plan in place you can sit down at your computer and begin the editing process.

THE INTERFACE

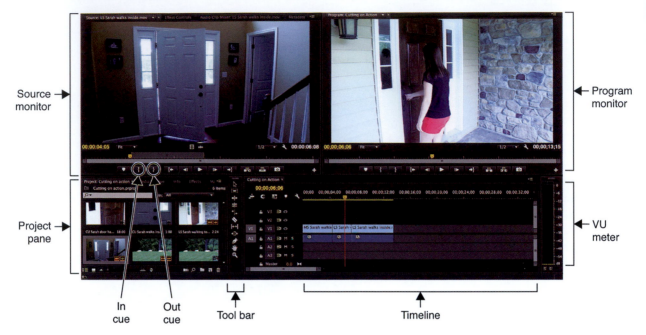

Source monitor

Program monitor

Project pane

VU meter

In cue Out cue Tool bar Timeline

Interfaces on nonlinear editing programs all look slightly different, but they contain the same components. This is the Adobe Premiere user interface.

Source monitor: This window shows you what your clips look like.

Program monitor: This window shows you what your edited video looks like. It's what your viewer will see.

Timeline: The timeline is what allows you to edit your project. There are audio and video tracks that allow you to combine your audio and video elements. You can think of it as a visual representation of what is in your program monitor.

VU (volume unit) meter: This shows you your audio levels. If you're not sure how to read these levels correctly, please see Chapter 4.

Project pane: This is where your video and graphics and any other elements that you'll use in your video are stored.

Tool bar: This area contains different tools that allow you to do different tasks.

In cue: Pressing this button sets an *in point* for your video. In other words, you are telling the computer where to begin editing the clip.

Out cue: Pressing this button sets an *out point* for your video. In other words, you are telling the computer where to stop editing the clip.

The timeline has places for both your audio and video.

Types of Edits

When editing video there are two different types of edits you can make. These are *insert edits* and *overwrite edits*.

INSERT EDITS

Insert editing is when you place a shot between two different shots. When a shot is placed in between the shots, it causes each shot to move over to make room for the new one.

Here's an example. Let's say you've shot video of a dog outside on some steps, and you've edited that together with a picture of the dog on the porch. You then realize you want to put video of the swimming pool between those other two shots. When you place the video of the swimming pool between the two pieces of dog video, without altering the dog video in any way, this is an insert edit.

OVERWRITE EDITS

Overwrite edits are different from insert edits. Overwrite edits cover any existing video in your timeline with the video clip you're putting into your timeline. Let's look at the same dog example from before. Let's say you want to do an overwrite edit over the shot of the dog on the steps. You want to replace the dog on the steps with a shot of just the pool. As you can see, the video of the dog on the steps has been replaced by the picture of just the pool.

Matching Pictures to Words

One of the most important lessons in editing is to match your pictures to your words. If you show a cat meowing, your audience expects to hear meowing. If the talent is talking about how horses are cared for, viewers want to see video of someone taking care of horses. If your script mentions horses being cared for and instead we see video of chickens, this creates a mismatch in the viewers' minds and they may not understand the message you're trying to convey. You may be wondering why there's a picture of a dog shopping if nothing in this paragraph references dogs or shopping. This only serves to prove our point.

Continuity

AXIS OF ACTION

When shooting and editing video you should be aware of the axis of action. The *axis of action* is the imaginary line along which action occurs in a scene. For example, someone swimming across a pool has a definite axis along which he or she is moving. If you are shooting video of this person swimming, in order not to cross the axis of action, you'll want to shoot from only one side of the pool. However, let's say you want to get video of the person from the other side of the pool. You head to the other side and shoot some video. When editing you want to make sure that you don't edit the two shots together (one from one side of the pool, and one from the other side of the pool) because it will make the person look like they are bumping into themselves.

Let's say you really want to use these two shots, but you don't want to confuse the viewer by crossing the axis of action. What should you do? Here are some tips.

Use a cutaway shot in between the swimming shots. In Chapter 6 you learned that a cutaway shot takes the viewer away from the main action in a scene. In this case using the cutaway shot will allow viewers to forget which way the action was moving in the previous shot.

Another way to avoid confusing your viewer is by getting a neutral shot as you cross the axis of action. In the swimming example, get video of the person swimming toward you. Once you have this video, use it between the other two shots as shown here.

You need to keep the axis of action in mind even when there isn't a lot of movement in the scene. For example, let's say you're getting video of two people having a conversation. You begin by shooting video of them talking from one side. You then decide to get video of them talking from the other side of the room. You then edit these two shots together. Look at what happens: it looks like the two people have switched positions on the screen.

Some editors may intentionally cross the axis of action and edit the shots together in order to disorient the viewer. Imagine that you're creating a video where a woman is being chased through dark streets by a killer. In order to make the viewer feel like they are part of the scene, you may choose to cross the axis of action.

LIGHTING CONTINUITY

It's important when editing to make sure your lighting stays constant within a scene. You don't want the subject to look bright in one shot and then dimly lit in the next.

SUBJECT APPEARANCE CONTINUITY

When shooting video, especially if it's over the course of several days or weeks, it's important to remember how your subject is dressed, as well as the placement of any props in the scene. If your talent is holding a pen in her right hand in the first shot, but then appears in the second shot with the pen in her left hand—that's a continuity error. If your talent is wearing her hair up in the first shot and then down in the second shot, this is also a continuity error. To avoid continuity errors it can be helpful to take pictures of the talent, backgrounds, and sets so you remember what they look like.

AUDIO CONTINUITY

Make sure your audio levels are consistent from one shot to the next. The viewer should not have to strain to hear your talent in one shot, and then feel like the talent is yelling at them in the next. Be sure to watch your VU meters.

JUMP CUTS

As you learned in Chapter 6, it's important to avoid jump cuts. You need to pay special attention to jump cuts during the editing process. Let's say you're shooting video of two people having a conversation. You place this shot in your timeline. You then place a shot of one of those same people talking in the timeline next to your first shot. Let's say in the first shot the female has her hands clasped in front of her and the male has his hands in his pockets. In the second shot they both have their hands in different positions. If these two shots are edited together, this is an example of a jump cut. The pictures on the next page illustrate how those two shots edited together would look. Do you see how the hand positions have changed from the first to the second shot? You want to avoid this when editing.

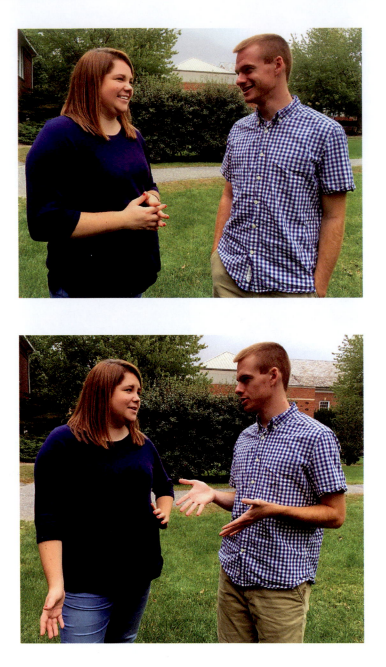

CUTTING ON THE ACTION

You can use the action in your scene to help you determine where to make your edits. For example, if you're shooting video of someone opening a door, you can cut on the action of the person's hand reaching for the door and then show the person coming through the other side of the door.

FLASH FRAMES

A *flash frame* is when an unwanted quick blip of black or unwanted video is seen between shots. This happens when you don't quite get the clips close enough to each other in the editing timeline and a frame (or a few frames) of black or unwanted video are visible. Sometimes these blips are so fast that they are barely perceptible, so make sure you watch your video closely.

To see an example of what flash frames look like scan the QR code.

Use of Computer Generated Effects

Editing programs have thousands of computer generated effects you can choose from. These effects are often easy to apply. Remember—just because you can apply these effects doesn't mean you should. Make sure any effects you choose add to your story and don't detract from it. You need to have a clear reason as to why the title screen you created flies on and off the screen, or why certain shots turn from color to black and white.

To see some examples of computer generated effects scan the QR code.

Editing Your Audio

As you learned in Chapter 4, the audio in your production is just as important as your video. If people can't understand your audio, they won't fully understand what your video is about.

USE OF MUSIC

Music can help you tell your story. The choice of music is an important one, as it can change the entire tone of your video. Use music to help create emotion in your scene. It can also be used to help with the pace of your video. Looking at silent video is often boring, but if you put some music under the same shots they suddenly seem to come alive and become more interesting to watch. It's generally not advisable to use music with words in it when you have your talent speaking, because you're forcing your viewer to concentrate on two separate sets of words. The viewer may end up singing along with the words to the song instead of listening to what your talent is saying. Instead, choose instrumental versions of songs.

To see an example of how music can be used in a video scan the QR code.

If you are not using original music (music you have composed or created yourself) you are going to need to use music created by someone else, which raises copyright concerns. Some companies and schools will purchase music libraries. The purchase of these music libraries will allow you to use the music, within the limits of the licensing agreement under which the tracks were purchased. Some music is also licensed under Creative Commons (CC). Those who have licensed their work under Creative Commons are giving you permission to use their work. If you are using something licensed under Creative Commons, please read the Creative Commons license with each work, so you are using the work appropriately. For example, some creators may not allow commercial uses of their work, or modifications of their work. For more information on Creative Commons go to www.creativecommons. org. You can also consider using music in the public domain. This music is the property of the public and may have, at one point, been copyrighted. Whenever you use music make sure you check all licensing agreements prior to beginning your project, to make sure you are using the music in accordance with the agreement.

CROSSFADES

In audio, *crossfading* is a technique where you bring up the audio level on one source, while bringing down the audio level on another source at the same time. This should be done smoothly, so that one sound seems to blend seamlessly into the next. For example, let's say you're using two different music tracks in your production. One is a hard rock song and the other is a pop song. In order to make the transition between these two audio tracks sound seamless, you should slowly fade down the hard rock audio track, and as the hard rock music is fading out, you slowly fade up the pop song.

NATURAL SOUND

As you learned in Chapter 4 natural sound (also called *nat sound*) is sound that you hear all around you. If you're in a computer lab you may hear sounds of people typing on computers, backpacks opening, and books being put on tables. When editing, it's important to make sure your natural sound matches what's going on in the video. For example, if you're editing a sequence where we *see* a crowd cheering but we don't *hear* the crowd cheering, there's a disconnect for the viewer. When we see people cheering, we expect to hear them cheering. If we see a person using a chainsaw, we expect to hear the chainsaw. Always make sure to use natural sound appropriately.

DISPLACING AUDIO

Sometimes there may be a problem with the natural sound you've recorded. Let's say you shot a sequence outside, and while you were shooting, someone yelled a profanity. You still want to use the video, but you don't want to hear the profanity. In this case you can do what's called *displacing your audio*. To do this, take a segment of sound from another place on the tape (maybe birds singing) and replace the audio of the profanity in the shot. This allows you to use the shot you want and to have natural sound. You could choose to remove the audio completely from the clip, but that would sound funny to the viewer, because the expectation is that they're going to hear outdoor sounds. When done well, natural sound should seem, well, natural. It shouldn't be jarring, and it should match what's happening on the screen.

LAYERING SOUND

Layering sound happens when you combine multiple audio sources. For example, you might have music, your talent talking, and nat sound all combined under a single shot. It takes skill and patience to make sure the audio levels for each of these separate sources are set correctly. You want to make sure the music doesn't compete with what the talent is saying. You also want to make sure your nat sound isn't so loud that your viewer can't hear anything else.

Editing Checklist

FOLLOW THESE 8 STEPS TO MAKE YOUR EDITING MORE EFFICIENT AND SMOOTH

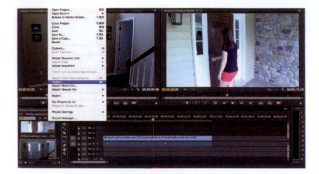

Step 1: Import Your Project Elements

Import the video you will use from your camera or SD card into the editing program. Also import any narration, graphics, music, and other elements into the editing program. Import only the elements you will use. This will allow you to save storage space. You will also save time when editing because you won't have as much to look through.

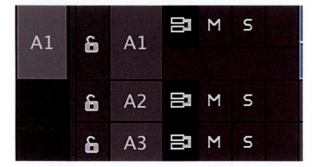

Step 2: Lay Down Narration and Sound Bites

Once you've imported your project elements, it's a good idea to lay down your narration and sound bites first. This will help you when it comes time to match your video to your audio. It's a lot easier to match your video to your audio than the other way around. Remember to watch your VU meters to monitor your audio levels.

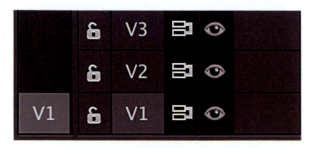

Step 3: Lay Down Your Video/Graphics

Now you can lay down your video and graphics to match the narration you've already laid down.

Step 4: Lay Down Your Music Bed

If you have a music bed (music that will play under your visuals and narration), now is a good time to lay it down under your narration. Remember, you don't want to use a music bed that has words because it will be distracting for your viewer. Instrumental pieces are a good choice for using as a music bed under narration.

Step 5: Add Special Effects

If there are special effects you'd like to use, now is a good time to add these. Note that some special effects, like those that speed up or slow down your video, may change the timing of the clip. If you are using these types of effects, you'll want to make sure you take this into consideration during your planning process.

Step 6: Watch Your Video

Watch the finished video from beginning to end. This is important, because you need to watch all of the edits you made within the context of the entire video. Also, sometimes your edits may not have turned out the way you expected.

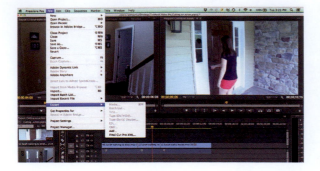

Step 7: Export Your Video

Once you've watched your video from beginning to end, you're ready to export it. There are many different file formats you can choose when exporting a video. The type of format you choose will depend upon how large you want your finished file size to be and how you want it to look. A large file size might give you great looking video, but it may be too large to upload to a website, or take too long for a viewer to load the file to watch. Conversely, a file size that's too small may leave you with grainy looking video and audio that's not easy to understand. File formats are changing all the time, so do some research to figure out which one might work best for your project.

Step 8: Watch It One More Time

After you export the video, watch it one final time to make sure there aren't any problems with the exported file. Technology isn't perfect, and sometimes things get messed up in the exporting process.

Activities—Put Your Learning into Action!

1. Use a video camera to shoot two shots that will allow you to *cut on the action*. Before shooting your video think about how you will combine the two shots.

2. Find a video clip that you feel is really well edited. Why do you like about the way the clip is edited. What techniques did the editors use?

3. Open up the nonlinear editing program you'll be using. Import at least one audio and one video clip. Once you've imported these elements do the following:

 - Add an audio clip to the timeline
 - Shorten the audio clip

- Add a video clip to the timeline
- Shorten the video clip you added to the timeline

4. Place a video clip in the timeline of whichever nonlinear editing program you're using. Add a special effect to the video.

5. Import music and narration into your nonlinear editing program. Practice combining these elements so the narration is easy to hear, but the music is still present enough to be heard. Make sure you're monitoring your audio by watching your VU meters.

6. Import narration and a video clip with natural sound into your nonlinear editing program. Practice combining the natural sound from the video clip with the narration. Make sure the nat sound is not so loud that it makes the narration difficult to hear. Also, be sure to watch your VU meters.

7. Load several video clips into your nonlinear editing program that have natural sound. Displace the natural sound from one clip to another clip. In other words, take the natural sound from one clip and place it with another.

8. **Service-Learning Activity:** Contact a local nonprofit organization. Using all of the skills you've learned in this chapter, as well as the previous chapters, write, shoot, and edit a 30-second and a 60-second PSA for the organization. Remember to begin by doing the preproduction work (research, media audit, treatment, scouting locations, storyboarding, etc.) before you begin shooting.

 To watch an interview with a professional scan the QR code.

Graphics

Graphics play an important role in most television productions. They can be used to give a unique identity to a program, identify people who are in the program, and help viewers understand where something takes place. Graphics, when designed and used properly, should enhance, not detract from, the overall look, feel, and message your production is trying to convey. This chapter outlines several different types of graphics you can use in creating your productions, as well as principles that you should keep in mind when designing graphics.

There are three responses to a piece of design—yes, no, and WOW! WOW is the one to aim for.
-Milton Glaser

It's through mistakes that you actually can grow. You have to get bad in order to get good.
-Paula Scher

Types of Graphics

There are many different types of graphics that can be used in productions. The choice of which graphic to use will be dictated by the information you need to convey and the type of video you're putting together. The following are some of the most common types of graphics.

FULLSCREENS

A *fullscreen* (FS) is a graphic that takes up the entire screen. These graphics can be used for program titles, to highlight important facts in a program or story, or to convey other important information to your viewer that you feel needs to be reinforced. Fullscreens can also be used to show pictures that relate to the program or story. For example, if you're watching a story about a murder suspect and you see a picture of that person that fills your entire screen—that's a fullscreen. If you then also see a map that fills your entire screen of the area where that suspect was last seen—that's a fullscreen too. And, if you also see a quote from the suspect that fills the screen, or a chart that shows how many crimes have been committed this year as opposed to last year—you guessed it—those are fullscreens too.

LOWER THIRD SUPERS

A *lower third super* (also known as *lower thirds* and *supers*) is a type of graphic that is superimposed over the bottom portion of a piece of video. Often when you watch a program, the name of the person and his or her title is seen on the lower third of the screen. Lower third supers can also be used to convey where something is taking place (called *locator supers* or *locators*). These generally consist of two lines—a general location (Lancaster County) and a specific location (Elizabethtown College). Lower third supers are a good way to convey information about who your viewer is seeing and where the video was shot.

CRAWLS

A *crawl* is a graphic that moves across the screen to convey information to your viewer. Crawls are often used to inform viewers about things without disrupting the program they are currently watching. For example, if there is severe weather headed to an area, a TV station may use a crawl during a program to let people know which counties are about to be impacted by the bad weather.

OVER-THE-SHOULDER GRAPHICS

Over-the-shoulder graphics appear—well—over the shoulder of the talent. These graphics, also called over-the-shoulder boxes, are used to visually reinforce what a story is about. For example, if you are watching a story about a new business that's coming to your town, there may be an over-the-shoulder box that says "New Business" and pictures a dollar sign.

 To see some examples of different types of graphics scan the QR code.

Key Design Principles

Before you begin to design your graphics you must first think about what role they will play in the show. Are they simply going to be used to identify people, or will you use them to explain difficult concepts that you're not able to show using video alone? Regardless of how they'll be used, there are certain key design principles and things you'll need to keep in mind when designing graphics for your videos.

ASPECT RATIO

High-definition television with 16 × 9 aspect ratio.

Standard television with 4 × 3 aspect ratio.

When designing graphics for television it's important to keep in mind the aspect ratio. The *aspect ratio* is the ratio of the width of the screen to the height of the screen. A high-definition television has an aspect ratio of 16 x 9, whereas a standard television has an aspect ratio of 4 x 3. When using design programs it's important to remember to choose the correct aspect ratio, otherwise portions of the graphics you designed may be cut off.

ESSENTIAL AREA

Not all TVs show the same amount of the picture on the screen, so it's important to understand the importance of the essential area. The *essential area*, also called the *safe title area*, is the area of the screen where you can be sure that everything you've put on a graphic can be seen by your viewer. When designing graphics it's important to remember not to put important information in the outer 10 percent

margins of the top, bottom, right, and left of the screen. If you do put information in those margins, there's a chance some people may not be able to see it on their TV screens. Most graphic design and editing programs allow you to turn on essential or safe area indicators. If you want to make sure that your text will be seen, regardless of what type of TV it will be viewed on, keep all essential elements within the safe title area of a 4 × 3 (standard television) aspect ratio.

COLOR

It's important that the graphics you make are easy to read. The use of contrast between the color of the letters and the background can help with this. For example, you wouldn't want to design a graphic with orange letters on a red background, because there's not enough contrast between these two colors. A good choice, when considering contrast, would be white letters on a dark purple background. Also, keep in mind that certain color combinations can make people think of different holidays. For example a green background with red letters may make people think of Christmas. A graphic that uses pastel colors may make people think of Easter. Keep in mind your target audience when choosing colors, because in different cultures colors can evoke different types of associations. In America, a red, white, and blue graphic may cause people to feel patriotic, but those colors used in a graphic in India may not evoke those same feelings.

READABILITY

Baskerville Regular
is an easy font to read

Party LET
is a difficult font to read

First and foremost you want to make sure the font you choose is readable. There are few things more frustrating than watching a video and not being able to read what's on the screen because it's in a fancy font. Which font do you think would be easier to read on a graphic—the one you're currently reading or an entire graphic made with this font (Curlz MT)? While there may be a time and a place for Curlz MT, it's not on a graphic that you want to make sure can be quickly and easily read by a viewer. You also want to make sure that the font size you choose is easily seen on the screen. Some people may be watching your video online, in a small box, so make sure your font is easily viewed on computers with small screens and on mobile devices.

Also, beware of busy backgrounds. It can be very difficult to read font over many different colors and images. If you choose to use a busy background, make sure your font is easy to read over all of the colors. Sometimes you may want to use a drop shadow on text to help separate your font from the background.

TYPOGRAPHY

After you've found a readable font, think about how different fonts can convey different types of emotions to your viewer. A font like *Apple Chancery* can convey a feeling of elegance, whereas a font like **Helvetica** is viewed as very clean and universal. The type of font you choose will depend on the type of show you're doing.

CONSISTENCY

Whichever font you choose for your graphics, you should make sure they are consistent throughout your production. You generally wouldn't want to use a certain font and color scheme for the first half of your program and then switch to a different type of color scheme and font for the last half. If you choose a blue background with white Helvetica font for your first graphic, you should stick with those choices throughout your show. This will provide visual continuity and a feeling of consistency for the viewer.

Chroma Key

In Chapter 2 you learned that *chroma key* is a process by which the talent is recorded in front of a green or blue background and then the green or blue in the background is replaced with another picture. Weather forecasters frequently use chroma key to show maps behind them while they're talking about the weather, but that certainly isn't the only application. You can also make it look like someone in the studio is sitting outside on a sunny day, or in a house, or in outer space. Make sure if you're putting your talent in front of a blue or green chroma key background that they don't wear blue or green, otherwise the background will also replace whatever they're wearing that matches the background.

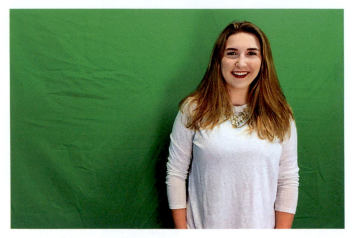

Person in front of a green screen.

Background over which the person will be chroma keyed.

Now it looks like the person is in front of the background.

VIRTUAL SETS

In a process similar to chroma key, virtual sets can also be used to create the illusion that the talent is in a different environment. Virtual sets are 3D graphics that allow the talent to look like they are immersed in a particular scene. Traditional chroma key is 2D, so when the camera zooms, the background begins to look out of proportion. Virtual sets use 3D modeling to allow the camera to zoom and still make everything look like it's in proportion.

Branding

No discussion of graphics would be complete without a discussion of the importance that graphics play in branding. *Branding* is the visual look that is associated with your program. For example, some news organizations like to brand themselves as "Coverage You Can Count On": they may use visual elements throughout their newscast that convey this idea to the viewer, so that the viewers come to associate the news station (the brand) with the idea that the station can be counted on all the time.

The station may also consistently use certain colors (perhaps blues) to convey a feeling of credibility to the audience.

Branding is also important in designing materials for clients. A client may want you to create a video with an "edgy" look that will fit in with other print materials that have already been created. In this case, make sure you are using elements (colors, images, wording, etc.) that are consistent with the print materials. The video you create should seamlessly fit the look and feel of all materials already created for the client. For example, if your client's current print materials use a silver, black, and white color palette you want to make sure these colors are used in the video you're creating.

Graphics Checklist

FOLLOW THESE 4 STEPS TO MAKE SURE YOU DESIGN GREAT GRAPHICS FOR YOUR PRODUCTION

Step 1: Role of the Graphics

Do you have a clear vision and plan for how graphics will be used in your video and what role they will play? If so, move to Step 2. If not, think carefully about how graphics will be used to help tell your story.

Step 2: Types of Graphics

Do you know what types of graphics you'll create? Will you need to create lower thirds, chroma key backgrounds, and/or fullscreens? If so, move to Step 3. If not, consider the types of graphics you need to make, and how long it will take you to make them. Often great looking graphics are very time-consuming to make, so you need to make sure you consider this when putting together a timeline for your production.

Step 3: Design of the Graphics

Have you thought about the colors and the font you will use to create an aesthetically appealing design? If so, move to Step 4. If not, think about appropriate colors you can use to help convey your message. Remember to choose appropriate colors for your background and font color. Also, make sure you have selected a font that is easily readable on both large and small screens.

Step 4: Consistency and Branding

Have you thought about how all of your graphic design elements will work together in your video? Are they consistent, and do they convey your brand or your client's brand? If so, you're ready to design your graphics. If not, you'll want to think hard about how you will create a consistent design throughout your video. Your font choice, color, and message should all work together to help convey your message. If you're working for a client you'll want to make sure you talk with them about making sure your video conveys consistent information about their brand.

Activities—Put Your Learning into Action!

1. Design a terrible graphic (one that violates the rules outlined in this chapter). Which rules did you violate when you created this terrible graphic? Now design a great graphic (one that follows the rules outlined in this chapter). Which rules did you follow to create this great graphic?

2. Watch a local or national television newscast. What branding elements are used in this newscast? Did they use consistent colors and fonts throughout? Were you able to figure out what the station's tag line (slogan) was when watching the newscast?

3. Watch a promotional video for a product or company. What branding elements do they use? Pay particular attention to fonts, colors, and wording to see if they are consistent throughout.

4. You're doing a promotional web video for a small clothing company called Waves. They have positioned themselves as a fun, hip company that sells beachwear (swimsuits, coverups, shorts, shirts, etc.). What colors and fonts would you use for these graphics? Design a lower third super, and a fullscreen that could be used in the video.

5. You're doing a promotional video for a large financial company called Cogswell Financial. They have asked you to produce a video aimed at getting upper-class investors to do long-term financial planning with them. They have positioned themselves as a trustworthy company and have a reputation for excellent customer service. What colors and fonts would you use for these graphics? Design a lower third super, and a fullscreen that could be used in the video.

6. **Service-Learning Activity:** Choose a nonprofit organization in your community. Look at its website, promotional videos, and printed materials (brochures, newsletters, etc.). Analyze how the organization uses branding elements across these different types of materials. Are the elements used consistently? What suggestions do you have for improving the materials?

 To watch an interview with a professional scan the QR code.

CHAPTER 9

Online and Viral Video

More and more people each year are watching videos online. While planning, shooting, and editing a video for television has many similarities to one produced for online consumption, there are some important differences. In an age where anyone with a cell phone and an Internet connection can create a video that goes viral, this chapter will explore ways to make your video stand out.

Content is King, Distribution is Queen.
-Andrea Febbraio

Viral videos aren't just about being funny. They're about identity creation.
-Ricky Van Veen

Shooting for the Small Screen

In recent years online videos have become very popular due to video sharing sites and the rise of smartphones. People enjoy sharing videos of themselves, their families, friends, pets—just about anything they can shoot, record, and distribute. At the same time, corporations, nonprofit agencies, celebrities, musicians, and politicians are using videos to help brand themselves. While many of the techniques you learned in the previous chapters apply to making web videos, there are some important differences to consider when shooting for an audience watching your video on a smaller screen, like a smartphone or a tablet.

HAVE A HOOK

Every video, whether it is for a large screen or a small screen, needs a *hook* to engage viewers. This is especially true for people watching videos on their phones, because they are often on the move and can get easily distracted. People's attention spans are getting shorter, so the hook needs to be in the beginning of the video. The hook can be enhanced with pertinent music or sound effects.

SHORT AND SIMPLE STORYTELLING

The shorter the better. You have to think about how to tell your story in the shortest and simplest way possible. On the video sharing service, Vine, videos need to be six seconds or less. You also want to have simple shots without a lot of distracting backgrounds.

CAPTURE LOTS OF CLOSE-UPS

Since people are viewing the videos on smaller screens, it helps to have a lot of close-up shots. Close-ups are good for storytelling—especially facial close-ups and people's reactions to what's happening. These types of shots let you see the subjects' emotions in the video. It also helps draw viewers into the video and keep them engaged.

LIMIT MOTION AND EFFECTS

On a small screen, lots of motion and special effects can be difficult to view. Using zooms and pans are often best left for the big screen. You want to make sure people can follow the action of your video without getting dizzy.

USE A TRIPOD AND A MICROPHONE

A tripod will help you avoid shaky shots. There is nothing worse than footage that is constantly moving all over the place. You can purchase tripod attachments for smartphones and tablets. If you can't get a tripod try placing your video camera, smartphone, or tablet on a sturdy object like a table. You can use a book or similar object to help prop it up and keep it still. You also need to think about sound quality in your video. If you want a higher sound quality than you can get with the built-in microphone on your recording device, then you might want to buy a high-quality microphone.

Don'ts for Shooting a Web Video

- Don't shoot distracting backgrounds. Keep shots fairly static and simple.
- Don't shoot images with lots of movement.
- Don't shoot busy, wide shots.
- Don't zoom in and out while shooting.
- Don't pan or tilt.
- Don't have subjects wear busy patterns such as stripes, floral prints, or herringbone.

Successful Social Media Campaigns with Videos

Videos have become a popular and powerful marketing tool. There are many examples of successful social media campaigns that have used video effectively. Companies such as Dove, Under Armour, and McDonald's have all used videos to help promote their brands or get their messages out. Some of the more successful videos do not outwardly promote a product. Instead, these videos engage viewers by educating them about an issue, problem, or cause through emotional storytelling techniques.

Successful Social Media Campaign Videos

- Dove Real Beauty Campaign #speakbeautiful
- The Amyotrophic Lateral Sclerosis (ALS) "Ice Bucket Challenge" #ALSIceBucketChallenge
- Under Armour #IWillWhatIWant
- McDonald's Super Bowl 2015 "Pay with Lovin'" #McDonalds
- Wrigley's Extra Gum's "The Story of Sarah and Juan" #GiveExtragetextra

DOVE REAL BEAUTY CAMPAIGN: "THE DOVE REAL BEAUTY SKETCHES" (2013)

The Dove Real Beauty campaign was launched in 2004 after a major global study, *The Real Truth about Beauty: A Global Report*, showed that only 2 percent of women around the world would describe themselves as beautiful. In order to help women love themselves and recognize that they are beautiful, Dove has made many videos. One example is "The Dove Real Beauty Sketches" video that is aimed at

showing women that they are more beautiful than they think. Dove asked several women to describe themselves to a forensic artist as he sketched their faces without seeing them. He then sketched them again based only on descriptions provided by another woman in the group. The sketches showed that women view themselves a lot more harshly than others do, and that women are very critical of themselves. The original video on the YouTube channel has had more than 66 million views to date.

What Makes the Video Content Compelling

The video has a unique hook. The viewer is drawn into the story of several women being sketched, but at first the viewer doesn't really know why the sketches are being made. Through sounds bites, soft music, and facial close-ups, it is revealed that women don't see what others do—their natural beauty. Further, the video's message resonates with women, causing them to share the video with friends and family around the globe. Unilever, who owns Dove, had the video translated into several languages, further assisting its ability to go viral.

THE AMYOTROPHIC LATERAL SCLEROSIS (ALS) "ICE BUCKET CHALLENGE" (2014)

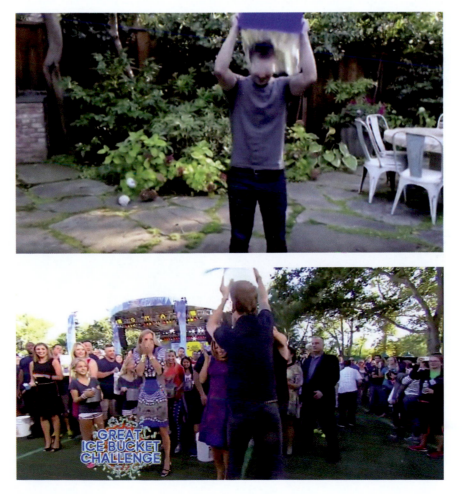

The ALS "Ice Bucket Challenge" promotes awareness of the disease amyotrophic lateral sclerosis (ALS, also known as Lou Gehrig's Disease) by encouraging people to dump a bucket of ice water on someone's head and donate to research. The campaign went viral on social media from July to August 2014, with many celebrities, athletes, and politicians also posting videos. *The New York Times* reported that "on Facebook more than 17 million 'Ice Bucket Challenge' videos were shared from June 1 to September (2014). More than 400 people viewed the videos more than 10 billion times." During the summer of 2014 the "Ice Bucket Challenge" helped to raise more than $115 million to combat ALS. (http://www.nytimes.com/2014/11/07/giving/ice-bucket-challenge-can-lightning-strike-again.html). On August 29, the ALS Association announced that its total donations from July 29 exceeded $100 million.

What Makes the Video Content Compelling

These videos ask people to engage in a simple act of dumping ice water, but they are able to use their own creativity in doing so. In the "Ice Bucket Challenge" we see people dumping icy water on themselves in a variety of settings, from their homes to beaches and even water parks. The hook of the videos is the dumping of icy cold water on fearful subjects. Further, the videos use simple storytelling with a basic script that is repeated in the open of each video. The subject names the person who chose him or her to do the challenge, and then he or she picks others to either accept the challenge or donate $100 to the ALS Association. These videos engage others by letting the people being challenged make their own video and post it. The videos encourage others to complete a simple altruist act. The videos also have a bandwagon effect by inspiring others to participate in a popular trending event.

UNDER ARMOUR "I WILL WHAT I WANT" (2014)

The athletic clothing company Under Armour launched a social media campaign using the hashtag #IWillWhatIWant. The campaign highlighted female athletes and encouraged all women of different shapes and sizes to get active. Under Armour continued its campaign with another video featuring model Gisele Bündchen. The video shows Gisele boxing. When the video first launched it cleverly used a website to display real-time social media insults about her from real people. Gisele is used to symbolize that women can be tough and strong even when facing harsh criticism. The campaign won many awards. It is also credited for increasing the company's sales by 28 percent.

What Makes the Video Content Compelling

The surprising scene of a sweaty supermodel, Gisele Bündchen, shown boxing is used to intrigue the viewer. The hook is the display of comments—mostly insults—aimed at Gisele that are being displayed on the gym walls. No voice track or music is used in the storytelling of this video. The sound for the video is comprised of her grunts, kicks, and punches during her workout. The video has a stark feel. Gisele is shown through mostly wide shots from different angles in the harsh, bare setting of a large gym with just a punching bag. The simple graphic "I Will What I Want / Under Armour" concludes the video and leaves the viewer with a message.

MCDONALD'S SUPER BOWL 2015 "PAY WITH LOVIN'" (2015)

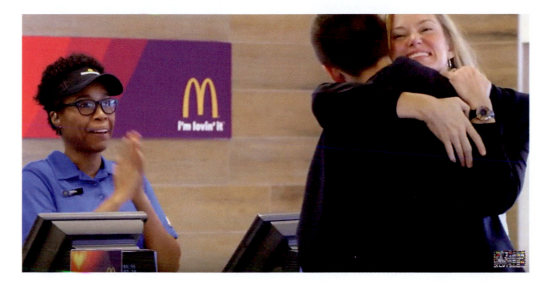

During the Super Bowl in 2015 McDonald's launched a social media campaign updating its "I'm lovin' it" slogan. After an eight-year hiatus from the Super Bowl, McDonald's aired the commercial "Pay with Lovin'," showing that customers could pay for their order with an act of love, such as calling their moms, doing a dance, or hugging their families. The spots ran through Valentine's Day, and customers were randomly selected to pay with love rather than money. During the Super Bowl, McDonald's also tweeted its love for the television commercials of other companies. McDonald's encouraged others to retweet its positive tweets about other companies by giving away prizes related to the commercials. During the Super Bowl, McDonald's received 634,000 Twitter mentions.

What Makes the Video Content Compelling

In this video the storytelling features real people showing their love through simple acts like hugging and dancing. It elicits a warm emotional response, with a mom hugging her son and an older man raising the roof for a free strawberry sundae. The footage almost has a home video feel, with shots of shocked customers engaging in these little displays of love and very simple graphics explaining the promotion. The hook is you can get free food at McDonald's if you show your love. The commercial engages the viewer by offering the hope that he or she might get randomly chosen to participate in acts of love and therefore get free food too.

WRIGLEY'S EXTRA GUM: "THE STORY OF SARAH AND JUAN" (2015)

Wrigley's Extra Gum's "The Story of Sarah and Juan" follows its 2013 "Origami" campaign, which shows a loving father and daughter relationship. "The Story of Sarah and Juan" is an emotional commercial that shows the love story of a young couple, from their initial meeting to their engagement proposal. The relationship's highs and lows are documented through Juan's drawings on gum wrappers, which are revealed through his marriage proposal. In its first week the video received 74 million views on the Internet.

What Makes the Video Content Compelling

This video uses suspenseful romantic storytelling to elicit emotions and at the same time sell chewing gum. A classic, familiar song underscores the video and helps tell Juan and Sarah's love story. Throughout the video we see shots of their relationship through their initial meeting, first kiss, prom, long distance relationship, and even an argument, before concluding with their engagement proposal. The story is cleverly intertwined with a hook of Juan's secret gum-wrapper drawings of each of these events, with a final big reveal when he proposes to Sarah. The video is beautifully shot with scenes in all of the seasons. The engagement proposal uses soft twinkling lights to further add to the tender tone.

What Is a Viral Video?

A *viral video* is a video that is widely shared on the Internet through websites, social media, and email. There are many different types of viral videos, such as those that capture ordinary life events, music videos, television clips, performances, political speeches, and commercials. Viral videos can make regular people and their pets a household name for doing extraordinary, or sometimes even ordinary, things. Many factors can contribute to the success of a video going viral. Popular videos are often posted on video sharing sites such as YouTube Charts, BuzzFeed, or PopStream. These videos are often shared on Twitter and Facebook, and may then be shown on traditional media talk shows or news programs. Not all viral videos were created with the intent of becoming viral. Some are created just for fun and

happen to catch on. Other videos capture everyday life events such as "Charlie Bit My Finger—Again!" (see below) and surprisingly become viral. No one knows exactly what will make a video go viral. There is plenty of content online with the potential to become viral that doesn't reach that wide of an audience.

The exact number of views necessary for a video to be considered viral is debatable. The popular YouTube comedian, Kevin Nalty, also known as "Nalts," blogged that a video could be considered "viral" if it hit a million views. However, Nalts changed his definition of viral to include a video that gets more than 5 million views in a three-to-seven-day period.

Examples of Viral Videos in Different Categories

Viral Video Examples

- Documentary: "Kony 2012" by Invisible Children, Inc.
- Music Video: "Gangnam Style" by PSY
- Performances: "The Evolution of Dance" by Judson Laipply
- Everyday Life Event with People: "Charlie Bit My Finger—Again!"
- Everyday Life Event with Animals: "Sneezing Baby Panda"

DOCUMENTARY: "KONY 2012" BY INVISIBLE CHILDREN, INC. (2012)

"Kony 2012" is a 30-minute documentary by filmmaker Jason Russell for the campaign group Invisible Children, Inc. It had more than 34 million views on the first day of its upload on March 5, 2012. This film shows the atrocities of east African war and Joseph Kony, who has led the Lord's Resistance Army in the jungle in and around Uganda. The United Nations and the International Criminal Court say that Kony, backed by child soldiers, has abducted, mutilated, and killed tens of thousands of children and adults. According to YouTube, as of November 2015, the film received over 100 million views and nearly 1.4 million "likes" on YouTube, and over 21.9 thousand "likes" on Vimeo.

What Makes the Video Content Compelling

This campaign video is well produced and uses excellent storytelling strategies to get viewers emotionally invested in the cause. The filmmaker and narrator, Jason Russell, tells the story of Jacob, a Ugandan boy, in order to inform others of the horrors caused by the warload, Joseph Kony. The viewer is told about the kidnapping, killing, mutilating, and raping of Ugandan children in simplistic terms without being too graphic. Further, Russell cleverly shares Jacob's story with his own young son, Gavin. He discusses the complex story in basic concepts. Viewers are able to see how a child processes such horrific events.

The video is also empowering and shows how people in America are taking a stand. In particular, it shows how the organization Invisible Children has influenced politicians and President Barack Obama to deploy American troops to central Africa. It has a clear message about how you can get involved and make a difference by purchasing a kit to help spread awareness about Kony and the Lord's Resistance Army (LRA). The video compares Kony to Hitler so viewers can clearly understand the magnitude of the situation. The video ends with a clear goal of hoping to influence 20 celebrities and 12 policy makers. At 30 minutes in length, the video is longer than most viral videos. However, the video is compelling and able to hold viewer interest.

MUSIC VIDEO: "GANGNAM STYLE" BY PSY (2012)

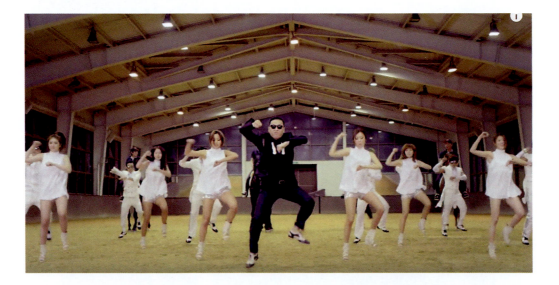

"Gangnam Style" is the eighteenth K-pop single by the South Korean musician PSY. As of November 2015, the music video has been viewed over 2.45 billion times on YouTube, which makes it the most

viewed video in the history of the site. On December 21, 2012, "Gangnam Style" became the first YouTube video to reach one billion views. The video inspired a slew of parodies, including versions with lifeguards, Navy midshipmen, and prison inmates in the Philippines that made the song even more popular.

What Makes the Video Content Compelling

A high-energy catchy song with a strong beat and lots of basic dance moves make this video engaging. A variety of locations are shown including a horse stable, a tennis court, and a steam room. The hook is the phrase "Gangnam Style," which is repeated many times throughout the video along with a hip-hop sort of dance step. The pacing is very fast with quick cuts and a variety of shots, which keep the video intriguing. The video is also quirky with a scene of PSY on the toilet and a close-up of a girl's buttocks. Further, the video features some choreographed dance segments with lots of dancers. It's interesting to note that most of the lyrics are in Korean, so people who don't speak Korean need to rely on the storytelling elements of the video to understand the lyrics. For example, to give viewers a sense of place the video shows images in Gangnam, an area in South Korea where wealthy young people live. Shots of a red sports car, well-dressed pretty young women, and a boat give context clues about the song's subject matter. The Korean lyrics may also add to the uniqueness of this history-making video on YouTube.

PERFORMANCES: "THE EVOLUTION OF DANCE" BY JUDSON LAIPPLY (2006)

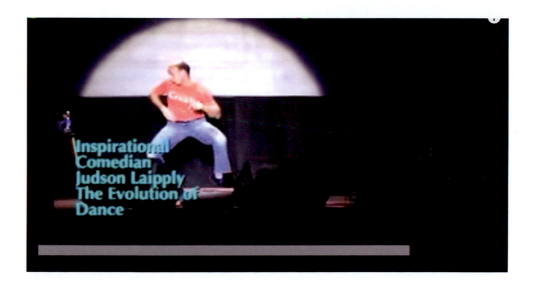

In 2006, dancer Judson Laipply uploaded a six-minute video in which he is performing dance moves to a variety of songs from different decades. The video, known as "The Evolution of Dance," received 70 million views in under eight months. As of November 2015 it has had more than 294 million views.

What Makes the Video Content Compelling

The content of this video is captivating. Laipply's dance routine is original, engaging, and sentimental. It resonates with people of many ages, since the music spans many decades. The entire sequence is six

minutes, which is longer than current popular videos. You need to keep in mind that the video was uploaded in 2006 shortly after the creation of YouTube. Since then, viewers have seen many similarly rehearsed video skits on YouTube that make "The Evolution of Dance" not seem quite as unique by today's standards.

EVERYDAY LIFE EVENT WITH PEOPLE: "CHARLIE BIT MY FINGER—AGAIN!" (2007)

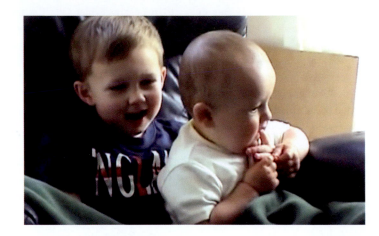

This 55-second Internet video was uploaded to YouTube in 2007. As of November 2015, it has had more than 830 million views. It features two English brothers, Harry Davies-Carr (aged three) and Charlie Davies-Carr (aged one). Harry puts his finger into Charlie's mouth and Charlie bites it. Harry says the line "Charlie bit my finger." The entire act is repeated again, but this time Charlie laughs after he bites his brother's finger. Due to the popularity of the video, the boys have appeared in advertisements and on talk shows. The boys' father said he originally uploaded the video to YouTube in order for the boys' grandfather in the United States to view it.

What Makes the Video Content Compelling

Young children, especially babies, are a captivating subject matter. In this video we see Harry's range of emotion from happy to sad and back to happy again after his brother Charlie bites his finger twice. There is also some humor, since it is Harry who puts his finger in Charlie's mouth the second time almost asking for it to be bitten. Then, there is Charlie's laughter after biting his brother's finger; it's enduring and mischievous. The video is relatable to many viewers who understand having a naughty younger sibling. Harry's British accent is also endearing. The storytelling is extremely simple but appealing to a wide target audience from children to adults. Also, the authenticity of the video (seeing the event unfold spontaneously) seems to add to its appeal.

EVERYDAY LIFE EVENT WITH ANIMALS: "SNEEZING BABY PANDA" (2006)

This viral video was uploaded to YouTube on November 6, 2006. It depicts a mother panda at the Wolong Panda Breeding Centre munching on bamboo while her baby cub sleeps at her feet. Suddenly, the baby sneezes, startling the mother for a second before she returns to her food. As of November 2015, the video had been viewed more than 218 million times.

What Makes the Video Content Compelling

Animals, like babies, are an appealing subject matter. This short 17-second video uses a single camera shot to show a mother panda who is startled by her baby sneezing. The video, which is simple yet humorous, offers a close-up look at the life of a rare and endangered species. The calmness of the video, with the mother panda eating, is disrupted by the shockingly loud sneeze from her baby. Due to the title of the video, viewers know what's going to happen but still watch for the anticipated sneeze. Then after the sneeze the mother panda resumes her eating. Viewers seem intrigued by this spontaneous natural event.

Tips for Getting Your Video to Go Viral

Tips for Getting Your Video to Go Viral

 V—Very Engaging

 I—Informative and Inspirational

 R—Really Short and Simple Storytelling

 A—Active Promotion

 L—Likeable Message

V—VERY ENGAGING

You need to have a hook that engages viewers. In the ALS "Ice Bucket Challenge" viewers are asked to take part in a simple, yet intriguing, altruistic act and then post a video. This act engages others and at the same time benefits a worthy cause. Similarly, McDonald's Super Bowl 2015 "Pay with Lovin'" (2015) engages people to take part in simple, enduring acts of love, such as giving hugs or dancing, for free food.

I—INFORMATIVE AND INSPIRATIONAL

Viewers are always looking for ways to better their own lives. It helps to give them news that they can use. Also, it is inspirational to see success stories—especially ones that beat the odds or ones that are uplifting. "The Dove Real Beauty Sketches" (2013) video evokes emotions to inspire and inform others. Based on Dove's (Unilever) 2004 global study that only 2 percent of women around the world would describe themselves as beautiful, the company sought to change perceptions and encourage women to see themselves in a different light.

R—REALLY SHORT AND SIMPLE STORYTELLING

Viewers have short attention spans that seem to be getting even shorter. Think about how to tell your story in 30 seconds or less. It helps to grab people's attention quickly or give them a reason to keep watching the video. In "Sneezing Baby Panda" (2006) you are anxiously awaiting the baby panda to sneeze. The Wrigley's Extra Gum commercial "The Story of Sarah and Juan" (2015) is a longer video at two minutes in length; however, at the root of this highly produced commercial is a simple love story with an intriguing twist that it is captured on gum wrapper drawings. Since you may not have the budget and means to make a video of this quality, keeping the video shorter, but still having a good story, is key.

A—ACTIVE PROMOTION

You need to promote your video through a marketing plan. In order to help your video go viral you need to start spreading it on social networking channels such as Facebook, Twitter, Huffington Post, Mashable, and Business Insider, just to name a few. Look for sites that have lots of traffic and followers connected to other social networking sites. The idea is that you want to increase your video's search engine rankings.

Does your video relate to any corporations? For instance, is there a chance for sponsorship? If you are making a video about cheerleading routines, link the video you've created to sites that promote cheerleading sportswear, sponsor cheerleading competitions, or highlight the songs used in the dance routines. Keep in mind that you do have to be careful of copyright and trademark infringement issues. You don't want to use trademarked logos or copyrighted music without authorized permission.

You also want to think about sites that relate to the subject matter of your video. For instance, if you are making a video about cheerleading routines then link to blogs and sites that deal with that subject matter. Think of good keyword terms that relate to your video and then use them to write a well-written description about the video. This will also help with search engine optimization (SEO). One of the free tools that you can use to determine what keywords are best is Google Keyword Planner. This tool has many features to help you understand how keywords work, how to build a keyword list, and how to identify the popularity of keywords.

L—LIKEABLE MESSAGE

In the end it helps if your video has good content through a likeable message. For instance, how do people feel when the video is over? Do they laugh, cry, or feel empowered? If you think about the videos listed in this chapter, most of them have positive messages. For example, Under Armour's "I Will What I Want" (2014) commercial is empowering to women. The message is that even a beautiful supermodel has critics, but she is not going to let them hurt her. Supermodel Gisele Bündchen demonstrates that she is strong and not going to listen to negativity; she wills what she wants.

You can also think about a likeable message in terms of what makes your video special or unique. You can ask yourself such questions as how does the video impact, entertain, or help others? Does the video use a teachable moment to inform? Is the video entertaining by offering viewers a quick break from their daily lives? Often viral videos are entertaining because they make people laugh. One of the factors that makes a video likeable is often humor. However, humor can be difficult to define, as well as to execute, because often what is funny to one viewer is not funny to another. If the humor is seemingly amusing in an inoffensive manner to a wide audience, such as in the videos "Charlie Bit My Finger—Again!" and "Sneezing Baby Panda," it can contribute to the success of a video going viral.

Another tip is to have your message relate to a current issue or trending topic. This could be helpful in making it a likeable message that is interesting or impactful to others and thus "viral worthy."

Compression

Before you put video on the Internet you usually need to compress it. This is normally done when you export your video from the video editing program. When you compress video, you may lose video quality. In general, the more you compress a video to make the file size smaller, the poorer the video quality will be.

Popular file formats are changing all the time. A file format that is widely used one year may not be used the next. It's a good idea to check the website you wish to upload video to in order to see if there is a file size limit and recommended format you should use.

Online and Viral Video Checklist

FOLLOW THESE 5 STEPS TO SHOOT A GREAT ONLINE VIDEO FOR SMALL SCREEN VIEWING

Step 1: Have a Hook

Do you have a hook to engage viewers? If so, move to Step 2. If not, think carefully about how to grab the viewer's attention. Remember, people have short attention spans and you need to get their attention quickly.

Step 2: Short and Simple Storytelling

Do you have a short and simple story you can tell? If so, move to Step 3. If not, think about the story you want to tell and how you can tell it succinctly. Even though the story is short, it still needs to be understood by your audience.

Step 3: Lots of Close-Ups

Did you get a lot of good close-up shots? If so, move to Step 4. If not, get some good close-up shots that will help you tell the story. While you'll also need to get long and medium shots, close-ups will be important to make sure your video looks great on a small screen.

Step 4: Limit Motion and Effects

Did you limit motion and effects? If so, move to Step 5. If not, remember to limit your use of pans, zooms, and tilts. Also, make sure you get shots that are not too busy and distracting.

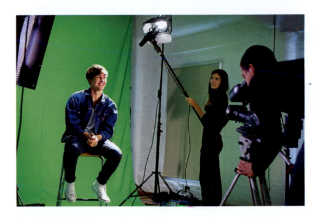

Step 5: Use a Tripod and Microphone

Did you make sure to use a tripod and microphone? If so, you're ready to shoot your video. If not, try to get a tripod. If you don't have access to one think about ways you can steady your shot without one. Also, an external microphone will usually provide the best sound.

Activities—Put Your Learning into Action!

1. Watch a video on Vine or YouTube. What storytelling techniques were used in only a few seconds?

2. What's your favorite viral video and why?

3. Watch one of the social media videos listed in the chapter. What's the "hook" in these videos, and how do they engage, as well as entertain, you?

4. Try making a six-second video for the web to sell your favorite brand of shampoo to someone else.

5. Now, try making a 30-second video for the web about a topic you really care about, such as your pet, your hobby, or your best friend.

6. **Service-Learning Activity:** Watch the "Kony 2012" video by Invisible Children, Inc. How does the video get you to care about the issue? What is the hook in the video? What storytelling techniques does the video use to keep you interested for 30 minutes? If you were to make a video for another cause or nonprofit agency, how could you apply some of the techniques used in "Kony 2012"?

 To watch an interview with a professional scan the QR code.

IMAGE CREDITS IN ORDER OF APPEARANCE

CHAPTER 1

Close-up of camera lens: © iStock.com/RGtimeline

Camera in blue studio: © iStock.com/DeshaCAM

On air sign with TV monitors: © iStock.com/PoppyPixels

Close-up of switcher: © iStock.com/Anthony Brown

TV monitors on black background: © iStock.com/Pgiam

Pie eating contest: © iStock.com/PamelaJoeMcFarlane

Puppy and kitty: © iStock.com/gurinaleksandr

Parade: © iStock.com/r_drewek

Empty classroom: © iStock.com/TERADAT SANTIVIVUT

Budget stories: © iStock.com/VladKol

Empty crime scene: © iStock.com/Terraxplorer

An iPad background: © iStock.com/AlexAndrews

Stack of DVDs: © iStock.com/Ugurhan Betin

Person typing on computer: © iStock.com/rocksunderwater

Person scouting locations: © iStock.com/strixcode

Camera and talent: © iStock.com/Anthony Brown

Budget sheet: © iStock.com/Paul Calbar

People with scripts: © iStock.com/Anthony Brown

Storyboards: © iStock.com/Shing Lok Che

Crew on location: © iStock.com/Jenny_Hill

In-studio shoot: © iStock.com/powerofforever

People meeting: © iStock.com/Georgijevic

Someone filling out survey: © iStock.com/Jirsak

Focus group: © iStock.com/sturti

Brainstorming table: © iStock.com/Rawpixel Ltd

Media audit at keyboard: © iStock.com/shironosov

Couple with remote: © iStock.com/PIKSEL

Talent in a production: © iStock.com/Anthony Brown

Cameraperson in the field: © iStock.com/majorosl

TV camera lens: © iStock.com/acitore

People meeting and working: © iStock.com/PeopleImages

Arrow: © iStock.com/ricardoinfante

QR code

Woman in front of camera: © iStock.com/Mihajlo Maricic

Camera at sporting event: © iStock.com/3DFOX

Woman with camera: © iStock.com/Cirilopoeta

Screenshot of "STEM Integration" video graphic: YouTube/https://www.youtube.com/watch?v=AlPJ48simtE

Screenshot of "STEM Education" video with Steven Chu: YouTube/https://www.youtube.com/watch?v=biWQZlUl-vE

Screenshot of "Bringing Science to Life" video: YouTube/https://www.youtube.com/watch?v=faMRXPhKntM

CHAPTER 2

Studio camera with purple background: © Shutterstock.com/DeshaCAM

Camera lens with on-air sign in background: © Shutterstock.com/Brisbane

Switcher: © Shutterstock.com/antb

Digital on-air sign: © Shutterstock.com/Itsra Sanprasert

Woman directing in control room: © Shutterstock.com/withGod

TV studio with cameras and crew: Authors

Arrow: © iStock.com/ricardoinfante

QR code

Standby cue: Authors

Cue talent: Authors

Stretch cue: Authors

Cut cue: Authors

30 seconds cue: Authors

5–4–3–2–1 cue: Authors

Wrap cue: Authors

Director: Authors

Assistant director: Authors

Technical director: Authors

Toaster operator: Authors

Audio operator: Authors

Teleprompter operator: Authors

VTR operator: Authors

Switcher: Authors

Arrow: © iStock.com/ricardoinfante

QR code

Chroma key screen: © Shutterstock.com/Rashevskyi Viacheslav

Director, directing a production: © Shutterstock.com/antb

Arrow: © iStock.com/ricardoinfante

QR code

Three-point lighting: Graham Lenker

Arrow: © iStock.com/ricardoinfante

QR code

Lighting plot: Authors

Fresnel light: © Shutterstock.com/ishkov sergey

Fresnel light with barn doors: © Shutterstock.com/GalapagosPhoto

Scoop light: Authors

Light meter: © Shutterstock.com/Andrew Buckin

Floor plan: Authors

Talent with a script: © Shutterstock.com/Olena Yakobchuk

TV studio with blue background: © Shutterstock.com/DeshaCAM

Close-up of human hand with pen: © Shutterstock.com/Champion Studio

Director reviewing script with crew: © Shutterstock.com/oliveromg

Talent in studio: © Shutterstock.com/claudia veja images

Director in control room: © Shutterstock.com/oliveromg

Arrow: © iStock.com/ricardoinfante

QR code

Switcher with close-up of fader bar: © Shutterstock.com/DJ Srki

Green screen TV studio: © Shutterstock.com/Yodchompoo

Talk show guests in front of camera: © Shutterstock.com/IxMaster

CHAPTER 3

TV studio camera: © Shutterstock.com/PHILIPIMAGE

Cell phone camera: © Shutterstock.com/antb

Consumer level camera: © Shutterstock.com/keellla

TV field camera: © Shutterstock.com/Rido

Girl with camera: © Shutterstock.com/PHILIPIMAGE

Studio camera: Authors

Field camera: © iStock.com/Schroptschop

XLS of girl at computer: Graham Lenker

LS of girl at computer: Graham Lenker

MS of girl at computer: Graham Lenker

CU of girl at computer: Graham Lenker

XCU of girl at computer: Graham Lenker

Audience at an event: © Shutterstock.com/Anton Gvozdikov

Boys playing soccer: © Shutterstock.com/Fotokostic

Arrow: © iStock.com/ricardoinfante

QR code

Person with camera very close to the subject: © Shutterstock.com/Haider Y. Abdulla

Bust shot: Graham Lenker

Knee shot: Graham Lenker

Two-shot: Graham Lenker

Three-shot: Graham Lenker

Over-the-shoulder shot: Graham Lenker

Arrow: © iStock.com/ricardoinfante

QR code

Walking toward the car: Authors

Close-up of hand on door handle: Authors

Getting into car: Authors

Key in ignition: Authors

Looking in mirror: Authors

Hands on steering wheel: Authors

Car driving away: Authors

Video camera and operator under blue sky: © iStock.com/dlewis33

Arrow: © iStock.com/ricardoinfante

QR code

Arrow: © iStock.com/ricardoinfante

QR code

Camera being white balanced: Authors

XCU of camera lens: © Shutterstock.com/IVY PHOTOS

Arrow: © iStock.com/ricardoinfante

QR code

Two people with cameras: © Shutterstock.com/PHILIPIMAGE

Camera white balance: Authors

Someone shooting a close-up: © Shutterstock.com/antb

Young woman holding a toothbrush: © Shutterstock.com/Tamas Panczel - Eross

Arrow: © iStock.com/ricardoinfante

QR code

Control room: © Shutterstock.com/mashurov

Someone shooting video with phone: © Shutterstock.com/AstroStar

Camera shooting anchor: © Shutterstock.com/wellphoto

CHAPTER 4

Handheld microphone on table: © Shutterstock.com/Kazarlenya

Boom microphone: © Shutterstock.com/

VU meter: © Shutterstock.com/handsomepictures

Reporter with handheld microphone: © Shutterstock.com/withGod

Audio board with headphones: © Shutterstock.com/OSABEE

Handheld microphone in hand: © Shutterstock.com/Brian A Jackson

Lavaliere microphone: © Shutterstock.com/antb

Headset microphone: © iStock.com/Steve Debenport

Shotgun microphone with windscreen: © Shutterstock.com/Luminis

Microphone attached to a boom: © Shutterstock.com/antb

Field camera with built-in microphone: © Shutterstock.com/Denis Rozhnovsky

Wireless microphones and receiver: © Shutterstock.com/photopixel

Windscreen on lavaliere mic: Authors

Windscreen for a handheld microphone: © Shutterstock.com/SpeedKingz

Windscreen for a boom mic: © Shutterstock.com/antb

Cardioid pickup pattern: Authors

Supercardioid pickup pattern: Authors

Omnidirectional pickup pattern: Authors

Audio board: Authors

Digital VU meter: © Shutterstock.com/Marko Cerovac

Analog VU meter: © Shutterstock.com/Viktorus

Arrow: © iStock.com/ricardoinfante

QR code

Operating a field camera while wearing headphones: © Shutterstock.com/domturner

XLR connector: © Shutterstock.com/Max Coen

Phone connectors: © Shutterstock.com/suphakit73

Mini plug: © Shutterstock.com/pbombaert

RCA Phono plug: © Shutterstock.com/Sascha Burkard

Interview on location: © Shutterstock.com/Salim October

Reporter with mic: © Shutterstock.com/DW labs Incorporated

Girl being interviewed: © Shutterstock.com/waldru

Cameraman with headphones: © Shutterstock.com/Pitroviz

Arrow: © iStock.com/ricardoinfante

QR code

Woman holding mic with press pass: © Shutterstock.com/imagestockdesign

Mic being put on someone: © Shutterstock.com/wellphoto

Close-up of audio board: © Shutterstock.com/Mert Toker

CHAPTER 5

Reporter preparing audio-video equipment for interview: © Shutterstock.com/Lucian Milasan

Couple with video camera: © Shutterstock.com/bikeriderlondon

Sports interview in Barcelona: © Shutterstock.com/Christian Bertrand

Mother and baby in viewfinder: © Shutterstock.com/Olinchuk

Friends watching video camera: © Shutterstock.com/bikeriderlondon

Father making video about son: © Shutterstock.com/Photobank gallery

Young girl with camcorder: © Shutterstock.com/Volt Collection

Media student being interviewed: © Shutterstock.com/DeshaCAM

Politician talking to reporters: © Shutterstock.com/wellphoto

Detroit firefighters: © Shutterstock.com/John Hanley

Picture of a cat: © Shutterstock.com/marinaks

Filming creative video footage with professional video camera: © Shutterstock.com/Yulia Grigoryeva

Wide shot: Authors

Medium shot: Authors

Close-up: Authors

Close-up: Authors

Close-up: Authors

Over-the-shoulder shot: Authors

Low-angle shot: Authors

How do you become successful: © Shutterstock.com/SpeedKingz

Baseball game with batter, catcher and umpire: © Shutterstock.com/Aspen Photo

Woman filming meal preparation: © Shutterstock.com/Photographee.eu

High-rise building burning: © Shutterstock.com/Gemenacom

Cute puppy on blue background: © Shutterstock.com/Conrad Levac

Camera operator at work: © Shutterstock.com/Maxim Blinkov

Storyboard panel of Jane Smith winning her last race: Susan Linder

Storyboard panel of Jane growing up on the racetrack with her father: Susan Linder

Storyboard panel of Jane being interviewed by a reporter: Susan Linder

Storyboard panel of Jane's college graduation: Susan Linder

Storyboard panel of Jane daydreaming about winning the Indianapolis 500: Susan Linder

High-angle view of group of happy multiethnic people raising hands together: © Shutterstock.com/bikeriderlondon

Woman being interviewed outdoors: © Shutterstock.com/DW labs Incorporated

Teenage boy recording video of himself in bedroom: © Shutterstock.com/SpeedKingz

Cameraman shooting a football game: © Shutterstock.com/AstroStar

Hot air balloons of Cappadocia: © Shutterstock.com/topseller

Young creative team working together: © Shutterstock.com/gpointstudio

Screenplay close-up: © Shutterstock.com/Mark Poprocki

Storyboard template: © Shutterstock.com/RealCG Animation Studio

Arrow: © iStock.com/ricardoinfante

QR code

TV reportage: © Shutterstock.com/Mikael Damkier

Three young men sitting on ground with video camera recording: © Shutterstock.com/dotshock

Video operator shoots a lake in the desert from a mountain: © Shutterstock.com/Maxim Petrichuk

CHAPTER 6
Film industry movie camera filming: © Shutterstock.com/wellphoto

Cameraman with camera: © Shutterstock.com/chaoss

Video camera in TV news set: © Shutterstock.com/SpeedKingz

Cameraman in TV studio: © Shutterstock.com/DeshaCAM

Video camera on tripod: © Shutterstock.com/Ruslan Rizvanov

Bubble on tripod: Authors

Tripod set at proper level for interviewing: © Shutterstock.com/antb

Arrow: © iStock.com/ricardoinfante

QR code

Camera filming sunset: © Shutterstock.com/mTaira

Taking photo of the Eiffel Tower: © Shutterstock.com/Zoran Karapancev

Woman taking video of her mother: © Shutterstock.com/Martin Novak

Rule of thirds: Graham Lenker

Too little headroom: Graham Lenker

Too much headroom: Graham Lenker

Correct headroom: Graham Lenker

Too little noseroom: Authors

Too much noseroom: Authors

Correct noseroom: Authors

Too little leadroom: Graham Lenker

Correct leadroom: Graham Lenker

Arrow: © iStock.com/ricardoinfante

QR code

Frame within a frame: Graham Lenker

Cameraman shooting cutaways of people in the water: © Shutterstock.com/cassiede alain

Arrow: © iStock.com/ricardoinfante

QR code

Cameraman with ocean in background: © Shutterstock.com/jan kranendonk

Jump cut, angle 1: Graham Lenker

Jump cut, angle 2: Graham Lenker

Arrow: © iStock.com/ricardoinfante

QR code

Visually pleasing background: Graham Lenker

Distracting background: Graham Lenker

Boring background: Graham Lenker

Alternating the way the talent faces: Authors

Alternating the way the talent faces: Authors

Businessman filming a website video: © Shutterstock.com/Labeque

Arrow: © iStock.com/ricardoinfante

QR code

Exterior shot: Graham Lenker

POV shot: Graham Lenker

Reverse-angle shot: Graham Lenker

High-angle shot: Graham Lenker

Low-angle shot: Graham Lenker

Interior shot: Graham Lenker

Establishing shot: Graham Lenker

Insert shot: Graham Lenker

Reestablishing shot: Graham Lenker

Transition shot: Graham Lenker

Reaction shot: Graham Lenker

Arrow: © iStock.com/ricardoinfante

QR code

Person shooting outside: Authors

Person shooting inside: Authors

Shooting outdoors on tripod: © Shutterstock.com/Denis Rozhnovsky

Outdoor videography with tripod: © Shutterstock.com/Deymos.HR

Shooting the night view of a city: © Shutterstock.com/Yen Hung

Camerman in action at amusement park: © Shutterstock.com/DoublePHOTO studio

Girlfriends taking a selfie: © Shutterstock.com/Monkey Business Images

POV shot of hiker taking photograph of mountains with smartphone: © Shutterstock.com/Poprotskiy Alexey

Filming in a studio: © Shutterstock.com/Pavel L Photo and Video

Arrow: © iStock.com/ricardoinfante

QR code

Journalists from different channels shooting an interview: © Shutterstock.com/Vereshchagin Dmitry

Camera operator working with his equipment: © Shutterstock.com/Rido

Man shooting video: © Shutterstock.com/aodaodaodaod

CHAPTER 7

Someone editing: © Shutterstock.com/sergey causelove

Close-up of knobs on audio board: © Shutterstock.com/Dabarti CGI

Hands above computer keyboard: © Shutterstock.com/Evdokimov Maxim

SD cards: © Shutterstock.com/Cloud7Days

Hand on mouse: © Shutterstock.com/jannoon028

Time code on flip screen: Authors

Time code in Adobe Premiere: Authors

Frame of video of skiing (1): Graham Lenker

Frame of video of skiing (2): Graham Lenker

Frame of video of skiing (3): Graham Lenker

Frame of video of skiing (4): Graham Lenker

Frame of video of skiing (5): Graham Lenker

Frame of video of skiing (6): Graham Lenker

Frame of video of skiing (7): Graham Lenker

Frame of video of skiing (8): Graham Lenker

Frame of video of skiing (9): Graham Lenker

Frame of video of skiing (10): Graham Lenker

Frame of video of skiing (11): Graham Lenker

Frame of video of skiing (12): Graham Lenker

Newspapers: © Shutterstock.com/qvist

Handwritten logging sheet: Authors

Handwritten logging sheet with sound bite: Authors

Arrow: © iStock.com/ricardoinfante

QR code

Adobe Premiere interface: Authors

Audio and video tracks in Adobe Premiere: Authors

Dog on stone steps: Authors

Dog on porch: Authors

Dog on stone steps: Authors

Swimming pool: Authors

Dog on porch: Authors

Dog on stone steps: Authors

Dog on porch: Authors

Swimming pool: Authors

Dog on porch: Authors

Dog shopping: © Shutterstock.com/Javier Brosch

Person swimming shot from one side: Authors

Person swimming shot from other side: Authors

Person swimming shot from one side: Authors

Cutaway shot of someone watching the person swim: © Shutterstock.com/garett_mosher

Person swimming shot from other side: Authors

Person swimming shot from one side: Authors

Person swimming head-on shot: Authors

Person swimming shot from other side: Authors

People having conversation: Authors

People having conversation from other side: Authors

Dark street: © Shutterstock.com/Katerina Planina

Person in bright environment: Authors

Person in dim environment: Authors

Person with pen in right hand: Authors

Person with pen in left hand: Authors

Medium shot of two people having a conversation: Authors

Medium shot of people with arms in different position: Authors

Arrow: © iStock.com/ricardoinfante

QR code

Arrow: © iStock.com/ricardoinfante

QR code

Arrow: © iStock.com/ricardoinfante

QR code

Sheet music: © Shutterstock.com/ww.BillionPhotos.com

Background of silhouette of hands to sky: © Shutterstock.com/Robert Adrian Hillman

Import menu in Adobe Premiere: Authors

Audio area of timeline in Adobe Premiere: Authors

Video area in Adobe Premiere: Authors

Digital VU meter: © Shutterstock.com/Snvv

Video with special effects in Adobe Premiere: Authors

Woman looking at computer on grass: © Shutterstock.com/FotoTravel

Export menu in Adobe Premiere: Authors

Man looking at computer in office: © Shutterstock.com/StockLite

Arrow: © iStock.com/ricardoinfante

QR code

Video camera on tripod: © Shutterstock.com/Vereshchagin Dmitry

Computer editing keyboard: © Shutterstock.com/Killroy Productions

Computer with two monitors: © Shutterstock.com/Eugene Buchko

CHAPTER 8

TV monitors: © Shutterstock.com/Rasulov

Chroma key in viewfinder: © Shutterstock.com/antb

TV remote: © Shutterstock.com/mady70

Young woman at computer: © Shutterstock.com/Daniel_Dash

Woman at computer: © Shutterstock.com/Pressmaster

Fullscreen graphic: Tara Siano

Lower third super: Tara Siano

Crawl: Tara Siano

Woman at anchor desk: © Shutterstock.com/RTimages

Arrow: © iStock.com/ricardoinfante

QR code

Person thinking at computer: © Shutterstock.com/wavebreakmedia

16 x 9 television screen: © Shutterstock.com/gmstockstudio

4 x 3 television screen: © Shutterstock.com/LesPalenik

Essential area: Authors

Poorly designed graphic—no contrast: Tara Siano

Well-designed graphic—good contrast: Tara Siano

Font used well: Tara Siano

Font used poorly: Tara Siano

Busy background: Tara Siano

Person in front of green screen: Authors

Chroma key background: Authors

Person in front of chroma key: Authors

Anchor in studio during live broadcast: © Shutterstock.com/withGod

Branding sign: © Shutterstock.com/Roland Ijdema

Person thinking at computer: © Shutterstock.com/Sergey Peterman

Woman thinking with graphics around her: © Shutterstock.com/PathDoc

Botanical logo: © Shutterstock.com/Johavel

Branding label: © Shutterstock.com/Aquir

Arrow: © iStock.com/ricardoinfante

QR code

TV studio chroma key background: © Shutterstock.com/khagphotography

Woman thinking at computer: © Shutterstock.com/mimagephotography

Anchor in studio during live broadcast: © Shutterstock.com/withGod

CHAPTER 9

A mother and daughter selfie: © Shutterstock.com/Dragon Images

Keyboard with social media icons: © Shutterstock.com/scyther5

Friends using digital tablet outdoors: © Shutterstock.com/William Perugini

Social media and networking signs: © Shutterstock.com/Oleksiy Mark

Girls laughing while looking at mobile phone: © Shutterstock.com/Sjale

Girl whispering in man's ear: © Shutterstock.com/sezer66

Cute baby making a funny surprised face: © Shutterstock.com/ana Blazic Pavlovic

Munich, time-lapse, special effects photography: © Shutterstock.com/EMS-DOP

Mobilography smartphone on tripod: © Shutterstock.com/Kislitsin Dmitrii

Video direction: © Shutterstock.com/Naiyyer

Screenshot of "Dove Real Beauty Sketches" video: YouTube/https://www.youtube.com/watch?v=XpaOjMXyJGk

Screenshot of "ALS Ice Bucket Challenge—Mark Zuckerberg" video: YouTube/https://www.youtube.com/watch?v=wr1uT5Ie7iI

Screenshot of "ALS Ice Bucket Challenge—Good Morning America" video: YouTube/https://www.youtube.com/watch?v=-YOSqYGqW6A

Screenshot of "Under Armour—Gisele Bündchen—I Will What I Want" (2014) video: YouTube/https://www.youtube.com/watch?v=H-V7cOestUs

Screenshot of "McDonald's 'Pay with Lovin'" (2015) video: YouTube/https://www.youtube.com/watch?v=HCmh8cBjUeM

Screenshot of Wrigley's Extra Gum's "The Story of Sarah and Juan" (2015) video: YouTube/https://www.youtube.com/watch?v=2Uyjor7TSMI

Surprised woman looking at her smartphone: © Shutterstock.com/Antonio Guillem

Screenshot of "Kony 2012" by Invisible Children, Inc. (2012) video: YouTube/https://www.youtube.com/watch?v=Y4MnpzG5Sqc

Screenshot of "Gangnam Style" by PSY (2012) video: YouTube/https://www.youtube.com/watch?v=9bZkp7q19f0

Screenshot of "The Evolution of Dance—Judson Laipply" (2006) video: YouTube/https://www.youtube.com/watch?v=dMH0bHeiRNg

Screenshot of "Charlie Bit My Finger—Again!" (2007) video: YouTube/https://www.youtube.com/watch?v=_OBlgSz8sSM

Screenshot of "Sneezing Baby Panda" (2006) video: YouTube/https://www.youtube.com/watch?v=FzRH3iTQPrk

Students looking at video: © Shutterstock.com/Syda Productions

Friends watching video: © Shutterstock.com/wavebreakmedia

Television interview: © Shutterstock.com/wellphoto

Friends watching a viral video: © Shutterstock.com/Racorn

Camcorder shooting a little girl: © Shutterstock.com/Pitroviz

Media student being interviewed: © iStock.com/sturti

Arrow: © iStock.com/ricardoinfante

QR code

Overhead of young woman with laptop: © Shutterstock.com/Africa Studio

Co-workers confer over laptop: © Shutterstock.com/wavebreakmedia

Woman with smartphone: © Shutterstock.com/Mooshny

Index